ARAL
SEA

MAP OF THE
EASTERN ISLA

• Bukhara • Samarkand

Oxus

Meshed

Nishapur

Kunduz
Balkh Prov. Badakhshan Prov.

Hindu Kush • Istalif

Herat Bamiyan Prov. Kabul •

AFGHANISTAN • Peshawar

Ghazni

Indus

Lahore •

• Multan

PAKISTAN

Baluchistan

Indus

INDIA

ARABIAN SEA

Map by Nobu Miyazaki.

IN SEARCH OF
PERSIAN POTTERY

IN SEARCH OF
PERSIAN POTTERY

by Mitsukuni Yoshida
translated by John M. Shields

WEATHERHILL/TANKOSHA
New York • Tokyo • Kyoto

A NOTE ON THE DECORATIONS. The cover design
employs the Nishapur-style peacock and calligraphy
motifs from the bowl in Figure 41. The chapter-
heading decoration uses the same peacock in an eight-
pointed star like that shown in Figure 5.

*This book was originally published in Japanese by
Tankosha under the title* Perushia no Yakimono.

First English Edition, 1972

*Jointly published by John Weatherhill, Inc., 149 Madison Avenue, New York,
N.Y. 10016, with editorial offices at 7-6-13 Roppongi, Minato-ku, Tokyo
106, and Tankosha, Kyoto. Copyright © 1966, 1972, by Tankosha; all rights
reserved. Printed in Japan.*

LCC Card No. 72-76402 ISBN 0-8348-1510-9

CONTENTS

CONTENTS

IN SEARCH OF
PERSIAN POTTERY

Chronology of
Dynasties Ruling Persia

Achaemenid	550–331 B.C.
Macedonian	331–c. 1st cent. B.C.
Parthian	250 B.C.–A.D. 226
Sassanid	226–641
Umayyad	661–750
Abbasid	750–1258
Seljuk	1037–1231
Ilkhan	1227–1336
Timurid	c. 1385–c. 1500
Safavid	1502–1736
Afshar	1736–1750
Zand	1750–1794
Kajar	1794–1925
Pahlavi	1925–

CHAPTER ONE
PREHISTORIC
EARTHENWARE

THE LEGENDARY NATION of Persia is present-day Iran, a land of deserts and plateaus. To the north of it lies the world's largest inland sea, the Caspian. The sturgeon, from whose roe caviar is made, inhabits these waters. Its eggs are fine and black. Sprinkled with a little lemon juice, they turn pale gray. A mouthful leaves one with an unmistakable taste of elegance.

We travel the Caspian coast under gray skies from which the rain pours day after day; the thatched-roof farmhouses are just as in Japan, but here drenched cattle stand among the dunes, staring at us with sad, round eyes. A downpour falls on the paddies, golden and ready for harvest, the fields cloaked in a thick, soupy fog. Of many visits to the Caspian, my recollections are all of rain and fog. The piers of the town port are rusted red from the continual rains. A boy in a town along the way once told me there are fifteen kinds of fish in the Caspian Sea.

Once across the Elburz Mountains, south of the sea, all becomes a stretch of deserts and highlands that reach as far as the Persian Gulf. There, people cluster among the huge Zagros Mountains, the two deserts of Dasht-i-Kavir and Dasht-i-Lut, and in the valleys. Villages and towns spring up wherever there is water. These are the life-giving oases.

Water. People who live here measure everything in its terms. Where water is plentiful, the oasis swells, becomes even a large city such as Teheran, the capital, or like the former old capital, Isfahan. Where water is scant, you find just a sprinkling of farm dwellings and a thin stand of wheat. A trip across Iran is a matter of threading the oases together. On this point past and present are one and the same: ancient Persia and its civilization sprang out of these same supportive oases. And earthenware, the earliest manifestation of Persian pottery, gives us a glimpse of one side of this civilization in prehistoric times.

All art reflects the awareness, mentality, and world in which its people live. The ways of thinking and conceptual systems of the ancients are completely apart from ours; things we conceive of as separate, they see as being quite homogeneous, the sum and substance of their world. And the myriad patterns incised on the pottery of long ago are never simple ornamentation: they are the language of the ancients, their prayers and grievances. Not every piece of ancient earthenware has a pattern. In fact, those without any decoration at all are in the majority. Earthenware painted red or inscribed with various patterns was not an affair of daily life. Rather it was for liturgical ceremonies. The designs were intended to reach out to a power above in prayer and ardent supplication. The images are quite supernatural. You find a definite likeness to the human form, but also a clear dissimilarity. This is evident in the Luristan deity of Figure 19. Here you find a highly vitrified terra-cotta piece. The hands are wrapped around a beaked jar in a gesture of oblation.

Any consideration of Persian prehistory inevitably brings Luristan bronzeware to mind. In 1929 and 1930, this ware of unique feeling found its way to European markets in great quantity. Most of it originated in the Luristan locale in the Zagros Mountains. All of it was unearthed by the people living there, a fact which made it impossible to ascribe either age or origin to the pieces. We can place it,

however, somewhere between 2500 and 500 B.C. Luristan bronze-ware is loved even today for its animal themes that typify the art of primitive Persia.

The people who used such bronzeware tilled the oases, pastured sheep and goats, and fought their battles as brave soldiers. The deity with the imposing nose and pointed shoes who appears in Figure 19 is one of the images they venerated.

What might be the use of the beaked jar he holds in his hands? This kind of vessel is found in various types of differing design, a trait of ancient Persia not limited to earthenware; bronzeware shared it. Figure 2 shows another type of beaked jar. This one was found in the ruins of Hassanlu near Lake Rezaiyeh, in northwest Iran. It has many companions as to form. The ribbing appears to be an attempt to imitate the embossing of metal jars in an earthenware medium, and the dark finish of this black piece has indeed the cold strength of metal.

The University of Pennsylvania Archaeological Expedition had already been excavating the ruins at Hassanlu for six years when I arrived there in 1959. The group was hard at work, in the typically American lighthearted way. The gray *tepe* (tells, or artificial mounds seen in ancient Persian ruins) were buried beneath a layer of soft, fine sand, and in the scorching sun they seemed to melt and rise in the shimmering heat.

Hassanlu fell when it was attacked by another tribe in or around the ninth century B.C. When the stone gates were excavated, the ruins revealed the city to have been ravaged by fire. A single skeleton was discovered, and beneath it a large golden bowl. The vessel had a mythological design. I had an opportunity to inspect the bowl in the Archaeological Museum of Teheran. It was completely inscribed, but in pieces. The rich gold color took my breath away. The day the city fell, its priest had tried to escape with the golden bowl, the symbol of the city. Inscribed with everything its people believed in,

the precious vessel formed the center of their universe. The city falls, and the priest embraces the sacred symbol forever in eternal sleep. Nearly 3,000 years have come and gone before we suddenly discover him here, turned into a skeleton.

The Luristan statue comes to our rescue in solving the riddle of the beaked jar. One other similar figure is now known. It does not have the serenity or poise of the Luristan deity, however. Both arms are raised high in a gesture of prayer; on the fingertips also rests a jar.

The jar could only be a vessel for holy water, the statue a god embracing sacred water, sprinkling it from on high—for the people of the oases, water was the font of life, was literally life itself, since no water, no wheat, no sustenance. And so the inevitable association with rain. Complete dominion over water, freedom by its means, was the desert divinity's worthiest attribute.

The holy water of the beaked jar slakes all thirsts. Sacred water was surely the wine of old. In West Asia wine is literally sacred. "Come, fill my cup!" cries Omar Khayyam. Wine was the time-honored product of Persia. Shipped to the East, it was the exotic "wine of grapes, the twilight cup" that inebriated the Chinese poets. The shape of the jar is obviously taken from the bird theme and related conceptions. The bird was thought to be a disciple of the deity and a transfiguration of the human spirit.

The conjoining of sacred water and sacred cup was of great import. The cup of Figure 20 comes from Tepe Siyalk. South of Teheran is the city of Kashan, immortalized as a pottery center, and in its environs are the extensive ruins of Siyalk. Here, Roman Ghirshman of France, during the years 1933–37, undertook three excavations, uncovering three cultural layers, the last of which was seen to be composed of seven distinct levels. In and around 1000 B.C. there had been a great urban culture here. In the picture Ghirshman paints, there was a fortified hill with palaces on top and ordinary dwellings beside it. Outside lay the lands tilled by the townsfolk. The stone

and brick must have been an imposing sight, standing out against the desert stands.

The present Tepe Siyalk however is a sorry scene. A hill strewn with earthenware, and not a soul in sight. I visited it twice. It is about five kilometers from Kashan. Make your way along in the blistering sun till a large hill rises up on your right, completely covered—or so it seems—with shards of red earthenware. This is Siyalk. What a stark sea of fragmented earthenware it is. In Japan, ruins are rare and finds few; excavations are made with the greatest care. But here in West Asia, there is unimaginable wealth to be had because whole cities are being excavated, while in Japan most finds come from solitary graves. In any case, Tepe Siyalk took my breath away. To think that all of this had once been a part of ancient life. It gave the hill a definite aura and made me feel somewhat strange.

An earthenware kiln was uncovered here, but it is very small; it has a firing compartment about two meters in diameter and less than fifty centimeters high. The biscuits were simply inserted and a fire was built below. Eighteen vents in the floor provide access to the outside. The path of its holes and vents to the stoking compartment are similar to those in present-day Iran.

This kind of kiln, the upper compartment for the actual firing, the lower one for building the fire, with an earthen grill between, somehow traveled East. You find the same construction and principle in the Chinese ceramic centers of around the twelfth century B.C. It existed even earlier, in the Lung Shan culture (also called the Black Pottery culture), about 1750 B.C.

And in Japan, too. North of Kyoto, near Iwakura, at a place called Kino, a red earthenware is shaped without the use of a potter's wheel. The kiln is akin to the one at Tepe Siyalk. The products are used in shrines and on home altars as vessels for offerings. In making them, the clay is kneaded by pounding with a wooden mallet. A small amount is held in the hollow of the left hand, then slapped and

stretched in the palm by the heel of the right. Next, the curved shape of the dish is formed by spanking it smartly ten times with the right elbow. The inside texture is made by applying a piece of cloth. The wheel is not used at all.

The kiln in Kino used for firing the vessels is equally anachronistic. The inside is cylindrical, about one meter wide and seventy-four centimeters high. A lattice, about forty-three centimeters off the ground, divides the upper and lower sections. There is an opening to the outside for stoking. Firing takes six to seven hours. It is really a small affair.

What is surprising is that, in a single firing, this diminutive kiln can bake seven thousand small plates, each three to six centimeters in diameter. This indicates that its cousin at Tepe Siyalk was also capable of a considerable output. Today only three elderly craftsmen remain to transmit this ancient Japanese technique. Besides this kiln there is a special one for glazed ware. We could ask here what might be the implications of the existence of the same style kilns in West Asia, China, and Japan.

The cup in Figure 20 is decorated with a large, black goat. This species still exists. In the design the horns are wavelike and elongated for emphasis. It too is a sacred representation. The horns seem to grow before our very eyes: they symbolize the mystic power of life. Their generally crescent shape is related to the worship of the moon, a symbol of water. Here then is another example of the ancient Persian sacrament involving holy water.

The black pigment used on the goat design is of iron composition, probably iron oxide. The earthenware of Tepe Siyalk is decorated in three colors: black, sepia, and red. The red is from iron, of course. I once had a chance to analyze the sepia, which turned out to be iron with a high manganese content. The white body and its colors, including a black polished appearance, points up the really rich color sense that was characteristic of ancient Persia.

Tepe Giyan is at the gateway to Luristan, about ten kilometers from the tiny town of Nehavand. Ghirshman also made excavations here. He ascertained that the fifth layer, the deepest, corresponds to the second and third at Tepe Siyalk. One notices that scavengers have also been busy in the vicinity, and much of the ancient earthenware on sale in Teheran originated here.

Giyan ware is extremely rich in design. The jars with pert little birds (Fig. 21), or long-horned goats (Fig. 22) exhibit extremely adept brushwork. The goat seen on the jar in Figure 23, whose reproductive organ is emphasized, is also of interest. Just as the breasts of goddess images are always enlarged, here the enlarged genitals are a plea for a plentiful harvest. The bull depicted on the jar in Figure 24, to judge by its crescent-shaped horns, can be grouped among the gods of the moon variety, and thus is also related to water. Among the jars unearthed at Susa is a magnificent rendering of a bull drawing the deity's heavenly chariot. Elsewhere the bull comes to symbolize winter; in the famed sculpture of Persepolis, a bull engages the lion of spring in fierce battle.

The birds on the jar in Figure 25, with wings like the teeth of a comb, betoken a new era. The religion of the Achaemenian empire was Zoroastrian. The highest divinity of this creed, Ahura Mazda, god of light and supreme creative deity, was always depicted with wings of an eagle. Even today in the West the double-headed eagle remains. Hints of it are found on this jar.

Giyan offers many pots that stand on three feet. The vessel of Figure 26 reminds us of Chinese tripod kettles and censerlike bowls. Mountains, described by continuous triangles, zig-zag water patterns, and lunar symbols decorate such vessels. The ornamentation on the small bowl in Figure 27 is of the same type. The black water-vessel tradition of third-century Parthia was also related to this (Fig. 28).

These ancient people expressed their supplications in pottery,

searching meticulously for appropriate symbolic representations for their gods. Idealized animal imagery was central, as in the Luristan image (Fig. 19). These efforts culminated in the kind of superb expression found in the magnificent stag, the splendid statue of Figure 1, from the Gilan district. The goat of Figure 29 and the humpbacked ox of Figure 30 are other examples. Prehistoric earthenware was thus born of a fusion of faith and art. The intensity of its execution reflects the tension of life in those times, the struggle that life entailed.

There are many valleys in the Elburz Mountains that separate the humid Caspian coast from the arid zones to the south. Many ruins have come to light in these valleys. There you find the Mazanderan district, from which came the Kalar-dasht, a large golden cup with the beaten image of three lions like that of Hassanlu. It rained constantly when I was there. It was so muddy I could hardly walk. Just a mountain hamlet shrouded in mist and rain, and in the center—heaved up like a hill—a huge *tepe*. I slogged my way up to it, and found it unbelievably big. I returned empty-handed save for a small souvenir, an earth-goddess figurine I had picked up at the top. The ruins in these parts have not been subjected to sufficient scientific investigation so it is hard to be certain about objects found here. What the village folk of Mazanderan and Gilan have dug up has been selling very well on the Teheran market. Only Dailaman in the Gilan district is being formally excavated, this by Tokyo University.

When I visited Iran in 1959, many of the Amlash findings from Gilan were available on the Teheran market. Antique dealers came just about every day to my hotel to hawk their wares: "Amlash findings, earthenware, glass beads, and whatever you like!" The summer heat of midday Teheran is quite intolerable. Shops and government offices close down; everybody takes a nap. Then about four in the afternoon, as the sun's strength starts to wane, the city once

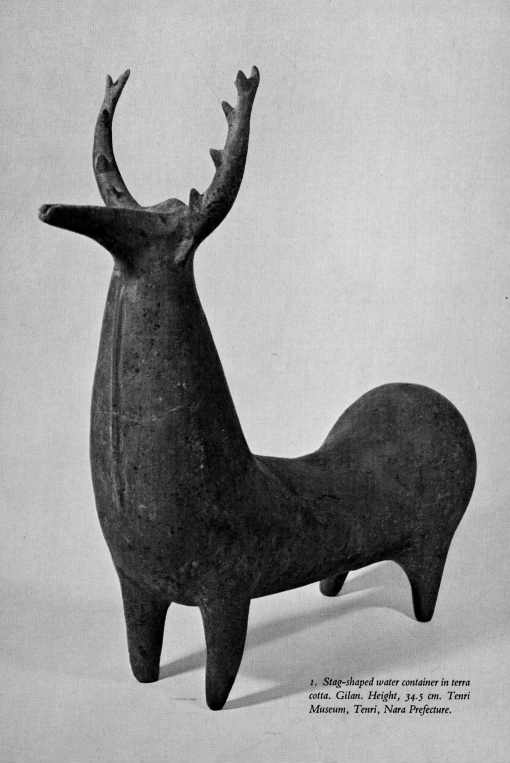

1. *Stag-shaped water container in terra cotta. Gilan. Height, 34.5 cm. Tenri Museum, Tenri, Nara Prefecture.*

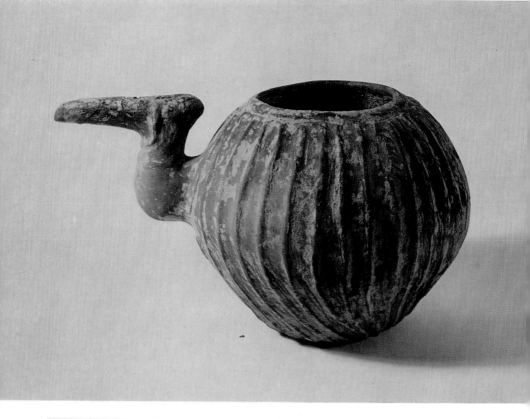

2. *Beaked black jar. Hassanlu. Height, 16.7 cm.; diameter, 20.1 cm.*

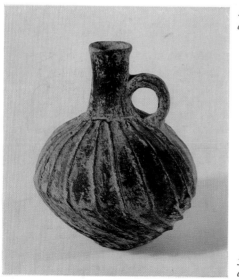

3. *Black water pitcher. Hassanlu. Height, 18.7 cm.; diameter, 16 cm.*

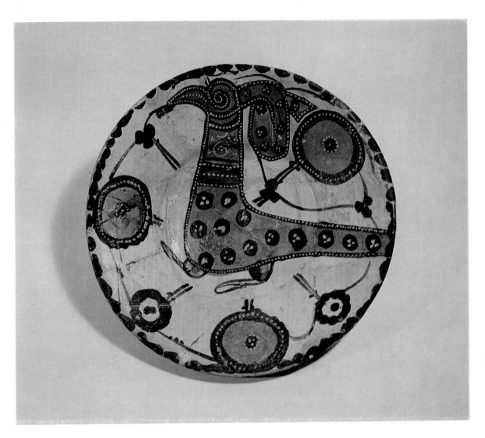

4. Multicolored dish with peacock and floral designs on white background. Sari. Eleventh century. Height, 5.3 cm.; diameter, 28.8 cm.

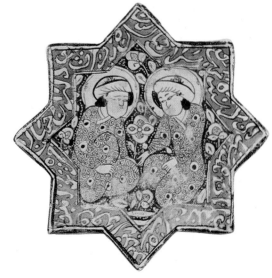

5. Luster-decorated star-shaped tile with two seated figures and calligraphy. Kashan. Thirteenth century. Diameter, 21.5 cm.

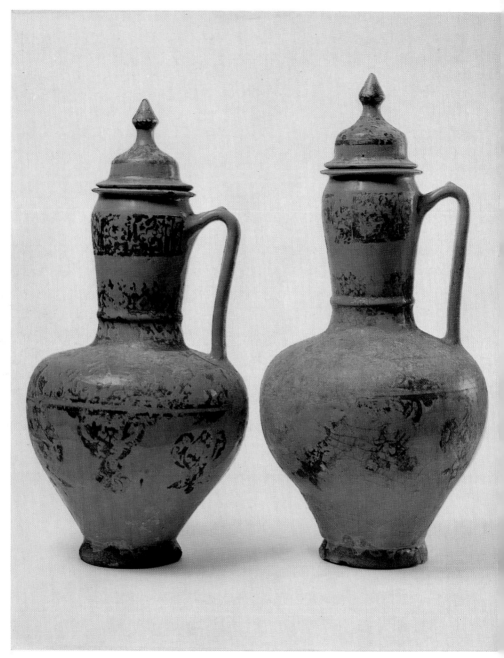

6. *Flasks with gold coloring and turquoise glaze. Saveh. Thirteenth century. Heights, 35.2 cm. and 36.5 cm. Idemitsu Gallery, Tokyo.*

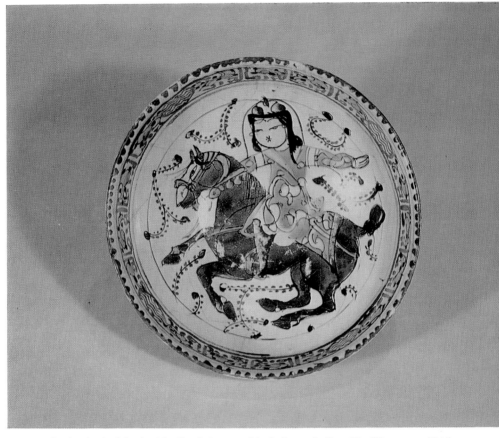

7. *Multicolored* minai *bowl with rider design on white background. Ray. Twelfth century. Height, 7.2
cm.; diameter, 6.6 cm.*

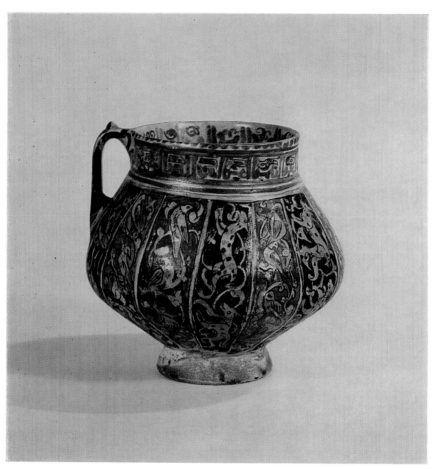

8. Multicolored minai *drinking cup with flora and fauna on white background. Ray. Twelfth century. Height, 13.3 cm.; diameter, 14.5 cm.*

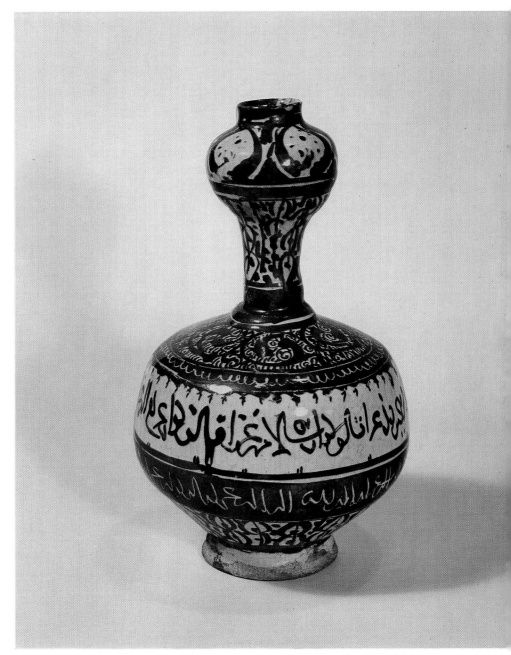

9. Luster-painted bottle with script design. Height, 23 cm.; widest diameter, 14.1 cm.

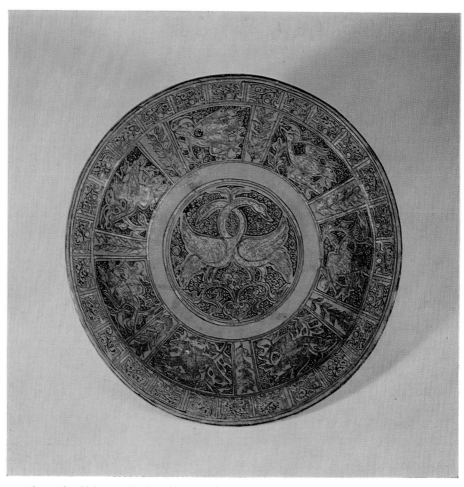

10. Plate with gold designs of birds on blue-green background. Sultanabad. Fourteenth century. Height, 7.5 cm.; diameter, 33.6 cm. Itsuo Art Museum, Ikeda, Osaka Prefecture.

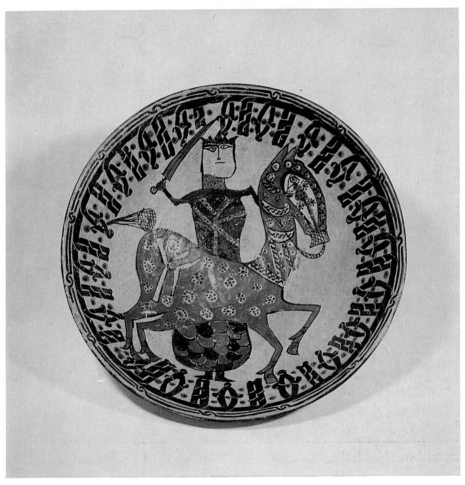

11. Bowl with horse-and-rider design in red and black on a cream background. The rim is decorated with calligraphy. Nishapur. Eleventh century. Height, 9 cm.; diameter, 29 cm. Tenri Museum, Tenri, Nara Prefecture.

12. Bowl with scattered red-and-black blossoms on white background. Nishapur. Tenth century.

13. Multicolored tile from Kubachi. Seventeenth century. Length, 18.3 cm.; width, 17.7 cm.

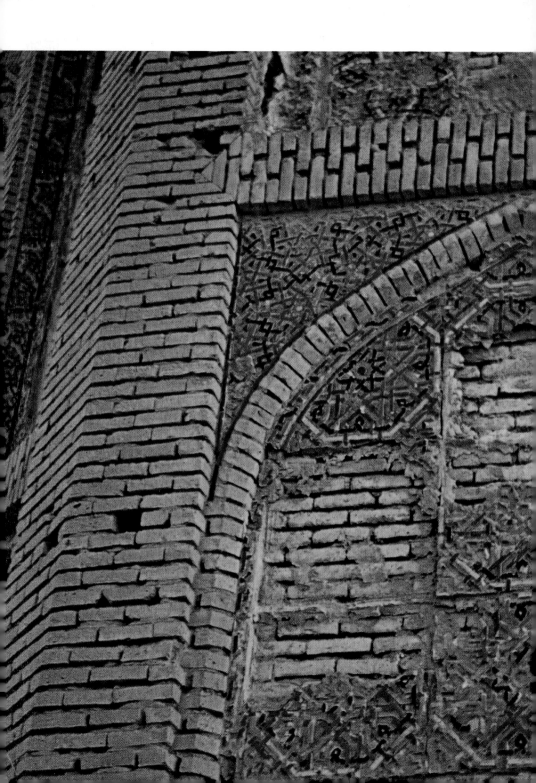

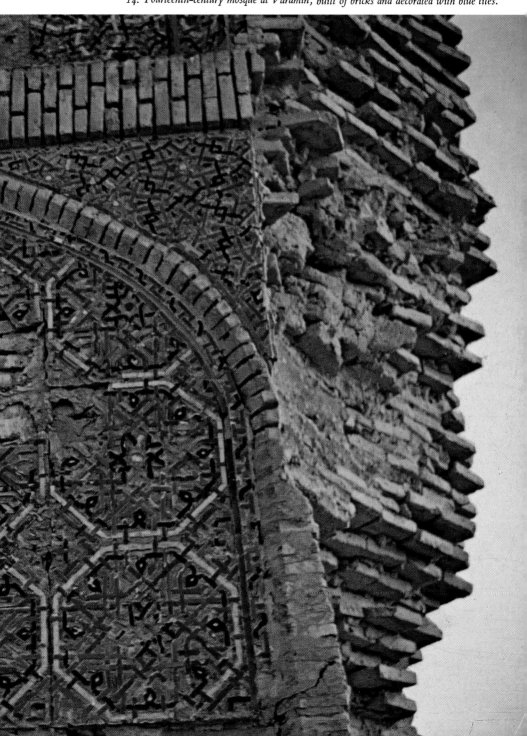

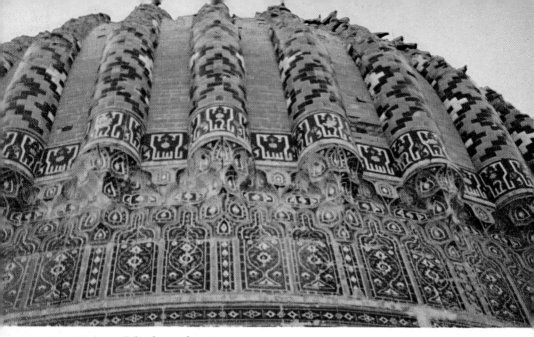

15. *Blue-tiled dome of the fourteenth-century mosque in Balkh, Afghanistan.*

17. *Tiled wall of the ▷ mosque in Herat, Afghanistan. Twentieth century.*

16. *Wall of an eighteenth-century tomb in Lahore, decorated with cedars and flowers.*

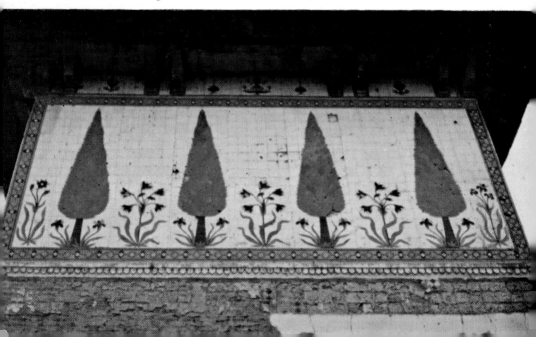

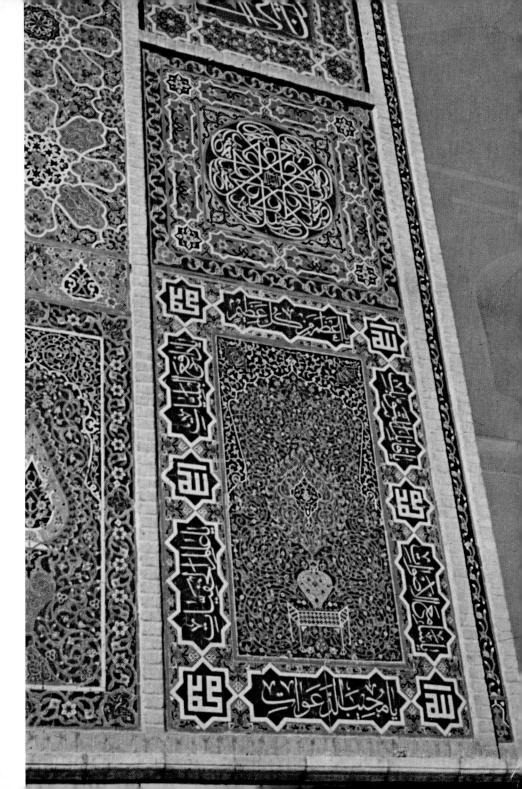

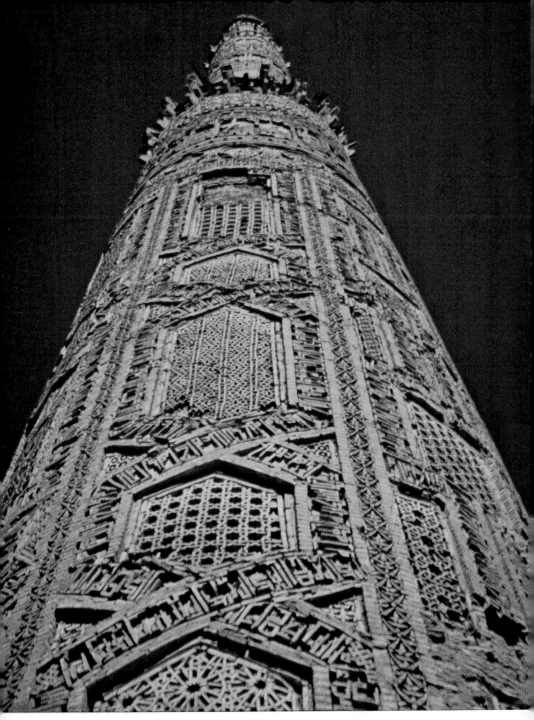

18. Arabesque brick mosaics on twelfth-century minaret in the village of Jam, Hindu Kush, Afghanistan. The section near the top is banded with blue tiles at a height of around eighty meters.

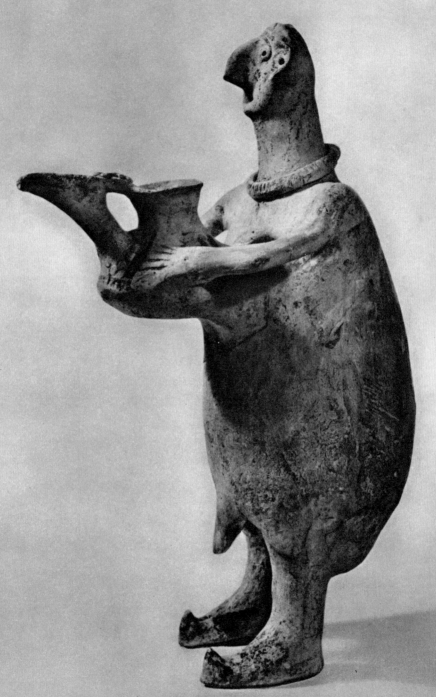

19. Terra-cotta statue of deity holding beaked jar. Luristan. Height, 39.4 cm.

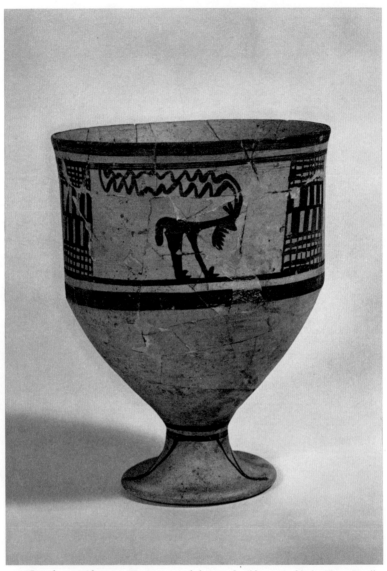

20. Sacred cup with geometric pattern and design of wild goat in black. Tepe Siyalk. Height, 18.8 cm.; diameter, 9.6 cm.

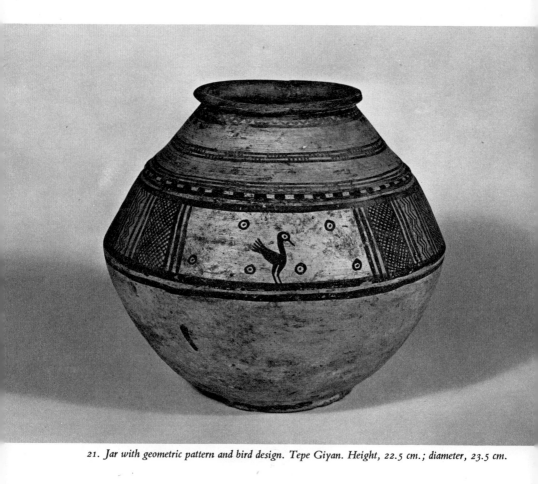

21. Jar with geometric pattern and bird design. Tepe Giyan. Height, 22.5 cm.; diameter, 23.5 cm.

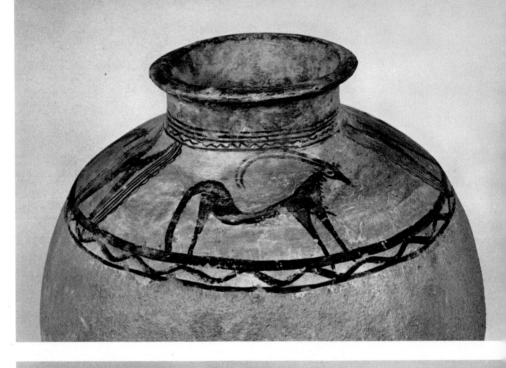

22. *Jar with long-horned goat design. Tepe Giyan.*
Height, 36 cm.; diameter at mouth, 14.2 cm.

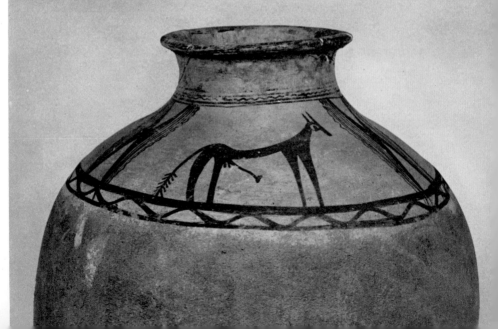

23. *Jar with wild goat design. Tepe Giyan. Height,*
38.2 cm.; diameter at mouth, 14.3 cm.

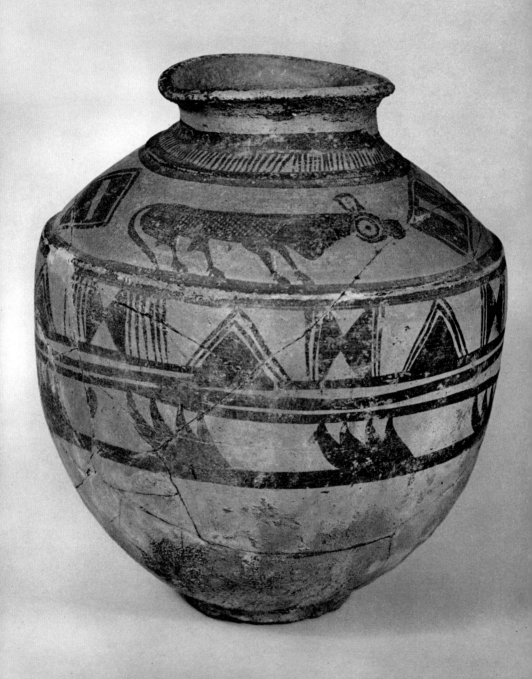

24. *Jar with geometric pattern and bull design. Tepe Giyan. Height, 34.5 cm.; diameter, 30.8 cm.*

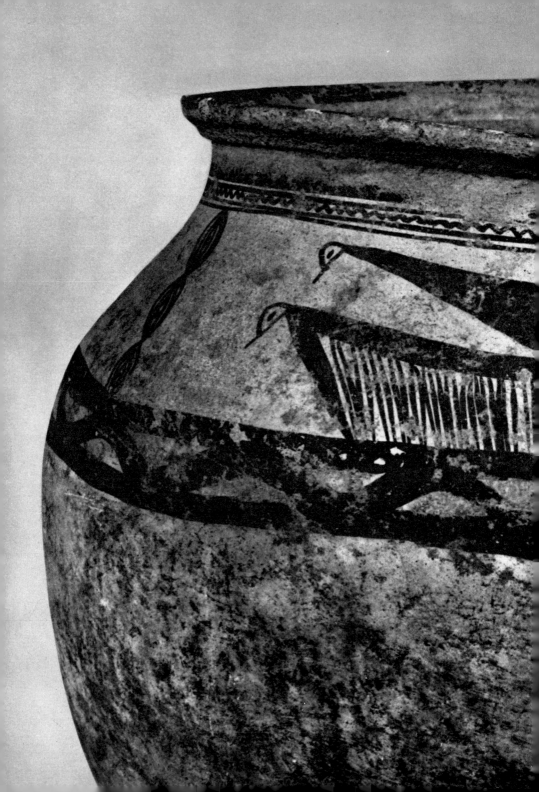

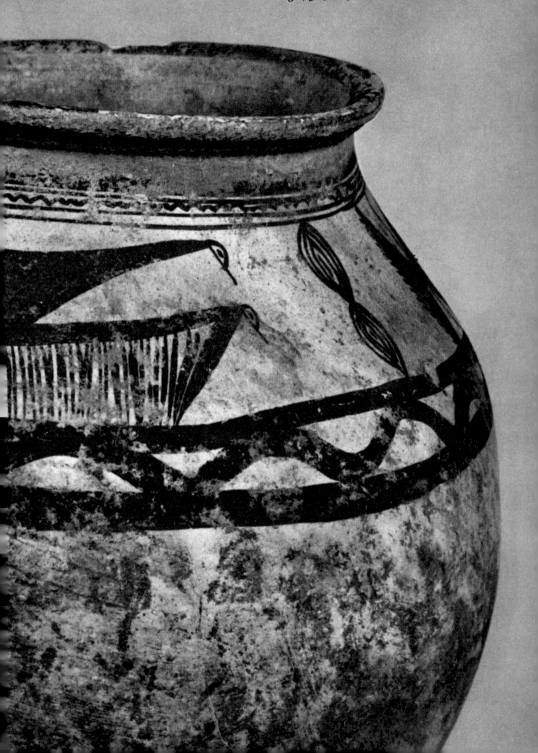

25. *Jar with double-headed bird design. Tepe Giyan. Height, 31.7 cm.; diameter at mouth, 28.2 cm.*

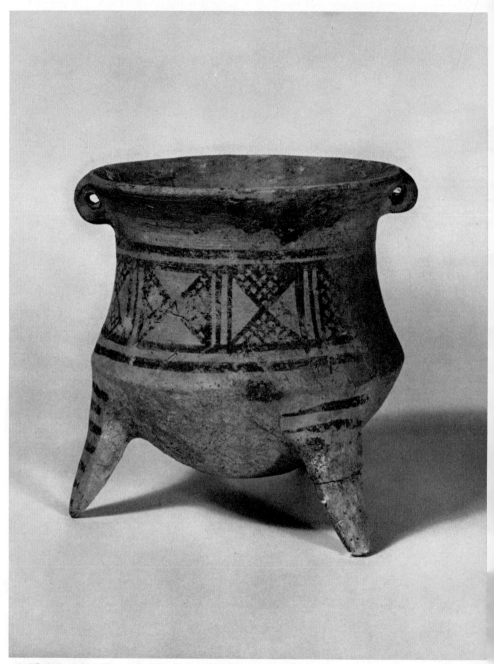

26. *Three-legged pot decorated with triangles. Height, 12.6 cm.; diameter, 11.3 cm.*

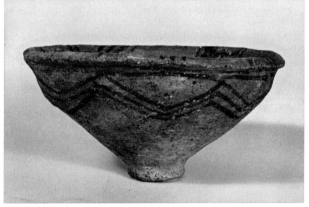

27. Two views of bowl
with geometrical design.
Height, 8.5 cm.; diam-
eter, 16.7 cm.

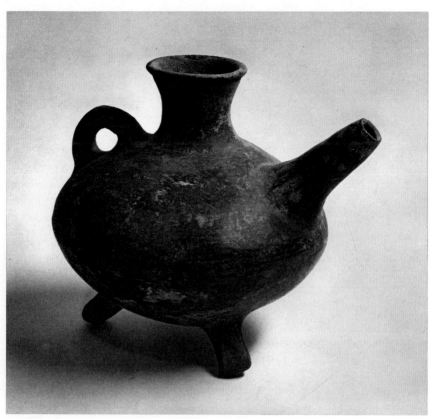

28. Three-legged black pitcher. Parthia. Height, 15.1 cm.; diameter, 15.8 cm.

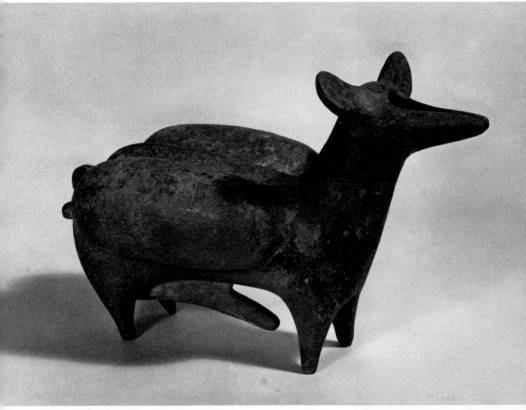

29. Goat-shaped water container in terra cotta. Gilan. Height, 15 cm. Tenri Museum, Tenri, Nara Prefecture.

30. Terra-cotta water container in form of hump-backed ox. Gilan. Height, 25 cm.

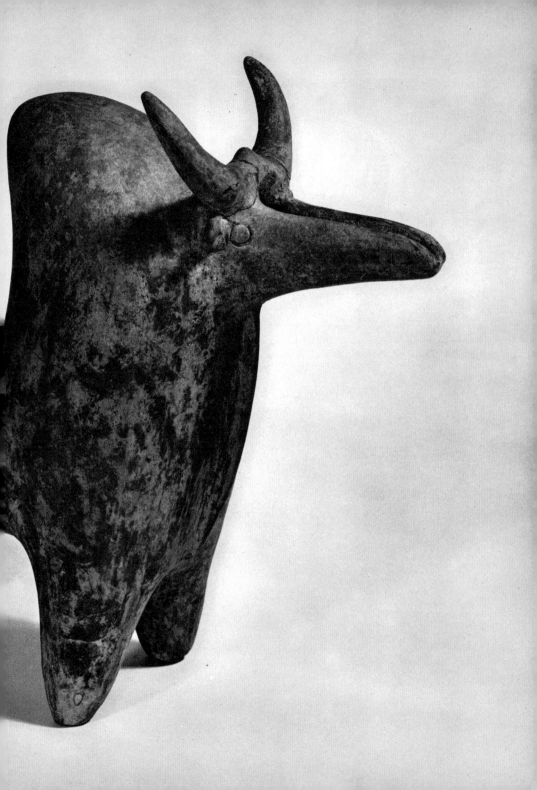

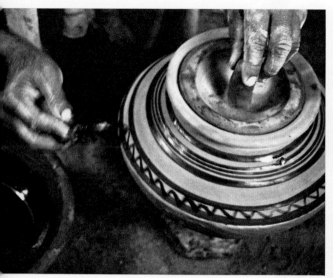

31. A potter of Larkana, Pakistan, decorates an earthenware vessel.

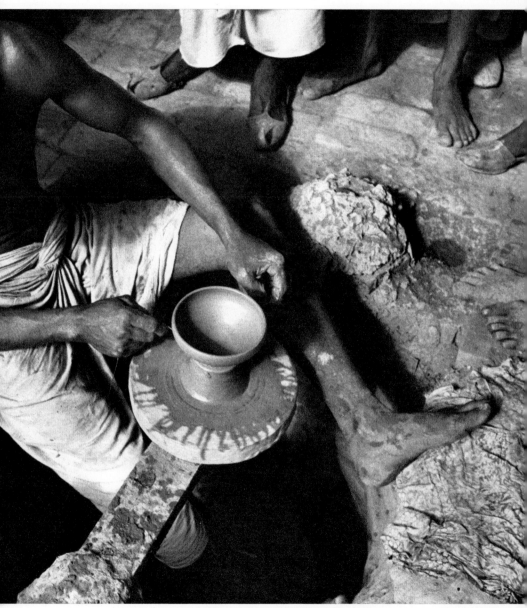

32. After a bowl has been thrown on a wheel, a cord is used to cut it off.

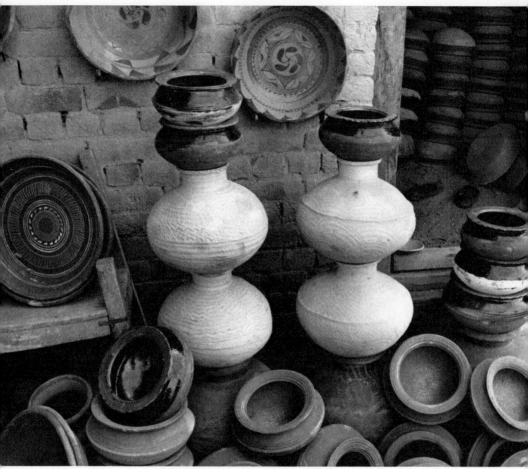

33. Decorated earthenware in front of a pottery in Multan, Pakistan.

again comes alive, with people rushing everywhere. Once I decided to take a stroll before supper, leisurely browsing through some antique shops. Everywhere I looked I saw Amlash, or what were claimed to be Amlash pieces. Amlash is actually the name of the town to which various finds were brought and distributed. Call it a clearing house. The real ruins are near Dailaman. Credit for this discovery goes to the Tokyo University Archaeological Expedition. The goat and ox mentioned above are thought to have come from there. They are both of excellent work, hard and well fired.

There seems to be no end to prehistoric ruins in Iran. Besides those at Tepe Siyalk and Tepe Giyan you have the well-known Susa excavations, long since undertaken by the French expedition, and then those of the Germans at Takht-i-Soleiman. Soleiman stands for Solomon, *takht-i* means throne; in other words, a site named after Solomon in all his glory. Over and above these there is Hassanlu, mentioned earlier, now being worked by the Americans. Nearer the Caspian to the north you find Shah Tepe, Turang Tepe, Tepe Hissar; in the south near Persepolis is Tall-i-Bakun; in the northwest, Ziwiyeh, origin of the golden vessel. The list goes on and on. And each place offers earthenware of great variety in design and type. The culture here certainly ran both wide and deep; scientific excavation has hardly scratched the surface. Meanwhile, plunder by the people goes its merry way.

The ongoing rape of the ruins forms the part-time work of many in impoverished Iran. Wheat is the only farm product and it is a single-crop yield at that. So in the off-season, during the winter, the people proceed to the *tepe* to dig up prehistoric earthenware and Islamic pottery. This is their winter employment. The vernal equinox is the Iranian New Year. Everyone knows there are things supposed to be eaten and new clothes to be worn. So they take their haul to the merchants of Teheran for whatever it might bring. This, incidentally, explains why the shops of Teheran are barren through

the winter but bulging before the New Year in spring. At any rate, this being the case, the provenance and place of excavation for much Persian pottery is no more accurate than finders' tales.

The Kyoto University Archaeological Expedition had been at work more than six years, pursuing excavations in Afghanistan and Pakistan for Buddhist Gandhara relics. Its work extended to the ruins of an immense palace near Peshawar, a large city in the north of Pakistan. Much black, decorated earthenware has been retrieved there. As with Iran, the volume is astounding.

The people of the farm villages surrounding Peshawar use earthenware of precisely this sort every day. In other words, in Pakistan the ancient, color-decorated earthenware is still alive and an essential item of daily life. For this reason, you still have the village potter there. The carpenter for furniture, the blacksmith for farm implements, and the potter—these three craftsmen are indispensable to the Pakistani village. And earthenware lives on beyond the rural pale. Go to the towns: the bazaars are always stocked with color-decorated earthenware. There are abstract, geometrical designs of black on red backgrounds, and rippling patterns smoothly rendered, all of them a testimony to living history.

I once visited a Pakistani village where such earthenware was made. It was another one of those hot days under the sun. Water was in abundant supply in the village because it was near the Indus. But for the same reason, the air was close, even stifling. In the small canal that wended through the village, water buffalo stood utterly motionless. The potter's house was poor, of mud like those of the farmers. Branches from trees were fixed to form an awning outside his house, underneath which stood his potter's wheel. It was wooden, of the kick type, set into a hole in the ground. The workman perches on the edge of the hole and rotates the wheel by foot. A small cubicle houses the clay materials. Alongside is a little depression in the earth into which water is poured to soften the clay. When the

right amount of water is absorbed, the clay is kneaded by hand on a board used for unglazed pottery. The wheel turns counter-clockwise.

We might take a look at how a water jar is made. A bowl-shaped biscuit is placed on the wheel. A thick coil of wet clay is made separately, then worked around and up inside the biscuit bowl. The lip and mouth are done with cloth; scraps of leather add the finishing touches.

The foot is formed separately. A small, malletlike instrument beats the clay; another wooden shovel-type affair is used to slap it into shape. The shovel follows the mallet's path in forming the bottom. Then the foot is simply stuck to the main body with slip.

Sometimes, of course, a simple pot or dish is made from a single piece of clay. As in Japan and elsewhere, a cord is used to cut the finished work away from the wheel (Fig. 31). When a jar is completed, the cover is put on and the whole is slapped hard on the ground. The air inside, trying to escape, gives the shape an exquisite uniformity of line—really an ingenious technique.

The vessel is then dried in the sun. After that design work can start. The brush, said to be of hair of a donkey's mane or tail, is made by fastening frizzled hair to the tip of a handle. The paint base is something like iron oxide.

Now a lid with a knob is snugly fit into the mouth of the jar. A small, round wooden board is nailed to another board in such a way that the round one provides a revolving pedestal. The jar is placed on it and is made to revolve, with the left hand grasping the knob, while the right applies the design with the brush. It's quite a thing to see. And in a matter of moments you have exactly the same, brightly done designs as are found on ancient earthenware (Fig. 32).

The painting is especially interesting because the wheel and revolving pedestal are used. Depending on the design, it is sometimes easier to have the piece on the potter's wheel. A pedestal for pattern

application could well have been the hand method used before the advent of the potter's wheel. Before the wheel just how was pottery made anyway? The most commonly known method was to take a long coil of clay and wind it around upward. Sometimes rings of clay were stacked one upon another, the gaps closed afterward by beating the clay with a wooden mallet. Enter the potter's wheel. It was the first tool to put into effect the principle of revolving motion in pottery production. Revolution here intends perpetual motion. The rotary press, so essential in the development of mass communications, turns out printed matter quickly, thanks to endless rollers. Revolution has thus figured tremendously in the development of civilization.

One comes upon curious shaping methods in Southeast Asia. A single stake is set upright into the ground and a small board attached thereto. A very long coil of clay is prepared, and one end of it is attached securely to the center of the board. Then a line of people hold the coil and walk round the stake to form a mounting spiral of clay. Here revolution is performed not by the tool but by men. But you wonder why the stake is not used as the axis and the board revolved instead.

In any case there is no kiln. The ware is simply stacked up in the sun to dry. The Indian process is similar: there they make a mountain of pottery, and shove dried manure in between for fuel. And in another Pakistani village, I saw a brick wall enclosure, one side left open, and pottery merely piled up inside. Whatever the method, it is plain that ancient earthenware developed despite the lack of a fixed form of kiln. It is not surprising that in Japan we find no kiln remnants for the Yayoi-period (200 B.C. to A.D. 250) earthenware.

Multan, another town in Pakistan. Accounts from travelers long ago mention the use of a potter's wheel made from large stones. I wondered if such was still used. I walked about Multan, its old ring of ramparts and many bazaars, in search of one. The earthenware

made there is usually color decorated. I came across some really beautiful things in one shop (Fig. 33). It looked like a pottery, so I peeked inside. Two men were working a potter's wheel in an open area within. But it was an ordinary wooden kick wheel. "You wouldn't have a stone wheel around, would you?" I inquired. The potter, a hulk of a man, went to a small storage room and dragged out a huge, round stone slab. It was nearly a meter in diameter and served as a stand for a stone wheel. It was very heavy. It was not actually an ordinary revolving wheel. A rod of thirty to forty centimeters long is driven into the ground to serve as an axis, fitting into a depression in the slab. Then the stone is slowly revolved to allow the potter to shape the vessel. In other words, you have a sort of revolving worktable. Multan potters no longer use it, they told me. I had once seen such a teetering stand at work in India.

While I listened I took a few pictures and notes. Before I knew it, the workmen had brought out coffee. It was sugary, not very tasty. And the cup was cracked. But it was somehow pleasant, squatting with them there on the dirt floor, sipping coffee and listening. Iran, Afghanistan, Pakistan—I visited each three times. In Iran they served me the usual black tea; in Afghanistan, it was often black, but sometimes green, as in Japan. These were friendly people, simple, goodhearted. They worked the wheel again and again for my benefit, proudly showing off their skill, and teaching me how to handle the clay. Japanese potters are like this too. They also have all kinds of devices for applying designs: small, homemade instruments, something makeshift stuck on a celluloid comb, or maybe a little wood chip to carve out all kinds of designs. When they show you their array of tiny tools, they too seem very happy, indeed.

CHAPTER TWO
THE ISLAMIC INFLUENCE

PERSIA BECAME A unified empire in the sixth century B.C., the time of the great king Darius I of the Achaemenian dynasty. The world of Persian culture extended from Central Asia to the district of the Indus in the east and in the west as far as Egypt. The Mediterranean and Egyptian cultures were also found here. And for the first time a single civilization was founded from several cultures.

It was the eastern expedition of Alexander the Great that cut across this civilization. Alexander conquered Darius III in 331 B.C. and occupied the entire country, advancing as far as the west bank of the Indus, there to build a new Grecian civilization. Troops were stationed throughout the region, and in each area colonial towns were set up and named after Alexander. Even today his name remains in Alexandria and in Kandahar in Afghanistan. The latter comes from the Persian name for Alexander, Eskandar. Alexander died young in Babylon, but the Greco-Roman culture he left took firm root in Asia. This was the Parthian age.

The Buddhist art of Gandhara is typical of the time. Lacking any earlier representation of the Buddha in human form, it was only around the beginning of the Christian era that such images came to be worshiped. Like their Hellenic counterparts, which clearly served as models for the Gandhara artists, Buddhist images were idealized

human forms. Temple guardians were modeled on Hercules and devout laymen were cast in the form of either Greek or Roman figures. Women wore the visage of Venus.

Roman power eventually supplanted that of Greece. The Sassanid dynasty (226–641) replaced the Parthian in Persia. The Sassanians once more began to shape a new culture distinct from any in the West, a blend of traditional, indigenous culture and Greco-Roman elements. In forming this culture, the well-traveled Silk Road played a major role, and Persia of the Sassanids was to grow in the confluence of two worlds, with Central Asia and China to the east, and Syria and Rome to the west.

At the Shoso-in, the eighth-century imperial treasure repository in Nara, Japan, there is a glass bowl originally from China, that was found among the artifacts in the tomb of Emperor Ankan in the Osaka district. Bowls made with precisely the same technique have been unearthed recently in great quantity in the Elburz Mountains of Iran. This shows a clear connection between Sassanian Persia and China. Moreover, the design of Sassanid silks, the lion and griffin motifs, living on today in the cathedrals of Europe, evince a marked connection with the world to the west.

The Sassanian period is most remembered for its fabulous gold and silver vessels. Every type of metallic art was employed—cast, embossed, damascene, cloisonné, metal carving, and niello. The designs are especially noteworthy. The color designs are those of ancient earthenware revived in a new medium.

Medallions, parallel lines, circles, squares, and the like are used to break up the surface spaces. Circlets are divided into quarters and octagons. Birds, beasts, stags, eagle pinions—all themes of prehistoric earthenware—are here. Once the cry of prayer and symbol of the spirit, they are now embellishments. Bright beauty has its day.

However, there are new designs here that cannot be found in ancient wares. You have the king at the hunt, his prerogatives and

gifts, the pleasures of the king and queen, and Anahita, the harvest deity. Sometimes there are scenes of people relaxing under a grape arbor, Chinese grape patterns, checkered patterns, and so forth.

What meaning can we draw from all this? We appear to be witnessing the twilight of the gods. The powers of the monarch come from above, are granted only to him who is king. We are moving into a different world. In ancient times, with Luristan bronze images, the animals of the earth were beholden to the "otherness" in the gaze of the gods. But in the Achaemenian sculpture of Persepolis and the golden vessels of the Sassanids, what clearly topples the monsters in battle is none other than the king himself, though he wears mere human clothes and countenance. The power to rule is the king's. It is no longer the gods: they are now somewhat reduced in significance.

The Sassanids saw four centuries of rule before Islam, which was born in Mecca, led by Mohammed, and swept into power in the East and West. The culture at the heart of Islam has continued to this day. Of the three great religions of the world along with Buddhism and Christianity, Islam is the newest. In its world conception exist only god and man, no intermediary. In this vein, it can be called a rather rational creed. Today Islam numbers four hundred thirty million believers and reaches from North Africa to Indonesia. Its extent is caught by the phrase, "from Gibraltar to the Philippines." In Iran and Pakistan, where it is the official, constitutionally adopted religion, Islam lives with the government itself; in Indonesia it is a mainstay of the state. In many lands, Islam embraces more than ninety percent of the people. Any understanding of the current problems of Asia and Africa is quite impossible without knowing Islam.

There are five basic tenets in Mohammedanism. First, there is no god except Allah, as Mohammed proclaimed. Second, prayer is obligatory. Third, a pilgrimage to Mecca is mandatory. Fourth,

almsgiving is encouraged. Fifth, during the ninth month, Ramadan, a fast from sunrise to sunset is rigidly enforced. These tenets remain unchanged up to the present and form the basis of Islamic society. Nevertheless, the world of Islam is an imperfect one. In Christianity, God made a perfect world and entrusted it to man. But in Islam, the world moves continually from an imperfect to a perfect situation. No god comes to save man and transport him heavenward. In Islam, God controls man, directs him, shows him the heavenly path. Thus man lives always at the behest of the divine.

The sacred book of Islam, the Koran, is hence quite different from the Bible. It is a set of rules to cover every phase of life: food, clothing, shelter, daily living, marriage, business, and travel. Everything is regulated right down to the last detail, since it is only by Allah's direction, the faith tells the believer, that life can be led to perfection. Sacred and secular are not clearly separate; rather, they mutually reinforce one another, the secular reaching realization first. In Christianity marriage is a divine sacrament, a union blessed by God to form a social unit. In Islam it is a mere human arrangement. And so it is only natural that Christians look askance at Moslem marriages. But one should not consider either as progressive or behind the times.

A pilgrimage to Mecca provides a renewed spring for the faith of the Muslim. Christians once journeyed to Jerusalem to seek the unity of Europe. This unity is a fact with Islam. Even believers "infected" by European civilization are imbued with a sense of history when they travel to Mecca. The pilgrimage fires their faith, gives each a kind of spiritual renewal.

It was in this world that Islamic art developed. But since Islam does not divorce itself from the mundane, it found itself conversely diluted by divergent traditions everywhere it went. Islam in Southeast Asia, in West Asia, or in Africa may be of a kind in faith and principle, but it is a bird of a different feather in each place, highly subject to

indigenous traditions. Consequently, Persian pottery, as one of the Islamic arts, evolved a distinctly Persian style.

ISLAM CAME TO Persia in the early seventh century with the Battle of Nehavand (641), which dealt the Sassanians a mortal blow. The Umayyad caliphs (661–750), headquartered in Damascus, took over, bringing Persia under Moslem control. This marked the inception of Islamic pottery, the core of Persian ceramics. Despite this fact, no abrupt change in pottery actually came about. The Sassanians had already left their mark. The Islamic capital, moreover, was in Syria. Roman and Byzantine influences swept in from the West to exact their toll. This explains the marked differences you have in Persian ware when you consider the Zagros Mountains as the dividing line between East and West Persia. In the East, the Sassanid tradition prevailed; the West went along with the Byzantine. Then there was the Silk Road, bringing conspicuous contact with China. Such factors charted the course of Islamic pottery. And by the middle of the eighth century, the Abbasid caliphate was in control in Baghdad, marking the definitive establishment of Islamic, i.e., Persian, culture.

Let us summarize the characteristics of Persian pottery. First, there is the white-glaze type mixed with tin. The tin is not pure. A mixture of lead and titanium produces much the same effect. The glaze tradition, begun as far back as the pre-Christian era, was known even in Assyrian times. Some have read in this the influence of Chinese white porcelain, but tin glaze has long been indigenous to West Asia.

Second, you have the use of cobalt designs on white. Cobalt blue was probably used as a substitute for lapis lazuli. Ever since the days of the Egyptian civilization, lapis lazuli, the specialty of Badakhshan in Afghanistan, was regarded as a precious stone in West Asia. King Tutankhamen's mask was reputedly of gold, and lapis lazuli was mentioned in the same breath with it. Its substitute was tur-

quoise, and the alternative cobalt and carbide copper used in blue-colored pottery. It was touted as being deeper than the blue of the sky, the color of kings, rulers of the earth.

Third, there is luster painting. Luster is obtained by applying cuprous colors onto a white glaze. It was discovered in Mesopotamia and widely adopted in Egypt, but not continuously so in Persia. The copper coloring is a deoxidized red. Since copper is highly volatile, this is no easy technique, which explains the faded colors of lusterware: the copper has simply undergone calcination. The underglazed ocher, said to have caught on in China under the Yuan dynasty (1280–1368), is derived from the same oxidized copper color. It is an Eastern tradition to use metal-based colors, but this underglazed ocher of Mongol times is quite likely a technique of the West.

Fourth, there is the use of dark green, alkali glazing. The color agent is copper, of course, of the oxidized type.

Fifth, you have cream, brown, and red glazes made with metals other than copper.

Sixth, there is pottery made in molds. The designs are applied and the pieces are fired immediately; or sometimes they are completely glazed in green. Molded pottery was most advanced in Syria. Persia imported it wholeheartedly, but it was not made there.

Seventh comes three-color, or polychrome, ware, which took hold in eastern Persia, especially at Nishapur. Yellowish brown, green, violet, and yellow glazes are applied. At first you would think they are the same as the famed T'ang polychrome ware. It has long been thought that the Persians were trying to copy the Chinese. Now Tsugio Mikami, Professor Emeritus of Tokyo University, and others, after recent findings, argue that three-color ware made its appearance in China a century earlier than it appeared in West Asia.

But was this three-color ware really Chinese in origin? China has a deep-seated monochrome tradition; celadon and white porcelain—both are a culmination of an attitude searching for beauty in uni-

formity. The incised designs are added, the result being a beauty enjoyed for its monochrome feeling. The beauty of the three Chinese colors is something else, a multicolored kind quite distinct in feeling. It is entirely different from, say, celadon or white porcelain. Here you have the reason for the short favor enjoyed by polychrome ware in China, why it soon became only history. Celadon and white porcelain, on the other hand, have remained popular up to the present. Perhaps the three-color designs had such an exotic quality about them that they found great favor and full flowering only during the T'ang dynasty (618–906). Add to this the fact that three-color Chinese ware was always used for interment. That is to say, it was used for burying with the dead and was not part of ordinary life. It is reported that only two Chinese polychrome items have been found among Western remains, those at Fustat in Egypt. This is logical because they were never basically a daily-use item.

Compare this with Persia where three-color pottery was an every-day affair. And not only in the eighth and ninth centuries either. It was made and used continuously long afterward. I myself have found pieces in tenth-, eleventh-, and even seventeenth-century ruins, all of the pervasive three-color kind. Would not the long usage indicate a feeling for polychrome ware quite indigenous to Persia?

Three-color designs in West Asian wares go back even further. In Babylon, about the sixth century B.C., the bricks in the city gates were glazed blue, brown, and yellow; the lion and stag were done in mosaic style. In Persia in the sixth century B.C., the walls of the Achae-menian palace at Susa were likewise glazed bricks of blue, brown, and yellow. The soldiers posted at the court were also represented in mosaic. Yet the potters, history reports, were from Babylon. Com-bining three-color glazes into a single pattern was a Mesopotamian tradition.

The materials for the palace at Susa, lapis lazuli and gold, were gathered in the north of the present Afghanistan and sent west.

Nishapur lies just above the route traveled, so it was only natural that Babylonian techniques and design found a home here. In other words, the earliest polychrome wares were developed in Mesopotamia and came east. The finds of the 1937 Metropolitan Museum Expedition at Nishapur are apparently of Mesopotamian origin. The lusterware also testified to this.

There is a ware called *raqabi* (Raqqa ware) which employs the three colors as a base, then adds others. We can place this anywhere about the middle of the twelfth century, halfway through the Seljuk reign (1037–1231). There are few extant examples. The designs are deeply incised and a different color glaze is used for each. The glaze colors do not mix because of the deep inscription. The color-glazed designs really stand out beautifully. The technique is said to have originated in Persia, but it is actually Chinese. It resulted in considerable pottery production in China throughout the T'ang and Sung dynasties (618–1279). Three-color glazing, laid claim to by Chinese craftsmen, now returns to Persia. Actually, it seems to have been more popular in Raqqa in Syria.

A nearly perfect example of this type is a plate from the Umayyad and Abbasid times, glazed sparingly and simply with green on a white background (Fig. 34). The center has black writing. Date it about the tenth century. In the same fashion, there is a dish from the same period in Figure 35 with white lettering on a brown background. The use of writing for design is a distinct trait of Islamic art. It often has a verse from the Koran or some congratulatory phrase. Also expressed are orations to Allah, as with the prayers seen on some prehistoric earthenware. The same are repeated in Chinese wares designed with the good-luck omens painted on porcelains from the Ming (1368–1661) and Ch'ing (1662–1911) dynasties.

On a plate with birds on a white background (Fig. 36), the birds are black, and drawn as if on a pond. Birds on water were a popular theme of prehistoric earthenware. They symbolized the spirits of

men swimming in the ponds of paradise. In this way, pottery transmitted the Persian myths. It is obviously a theme of reincarnation.

Arthur U. Pope, the editor of the multivolume *A Survey of Persian Art,* considers this kind of thing to be from Transoxiana, that is from beyond the Oxus River. The Oxus divides present Afghanistan and Russia. The provenance is placed well beyond the Oxus into Central Asia, near Samarkand and Bukhara. But the Metropolitan Museum Expedition mentioned above found pieces of this kind at Nishapur, one of the earliest production centers of Persian pottery. That pottery designed in the Samarkand style could be found at Nishapur is no cause for surprise. The small dish with a spiral design, pure black on a white ground, also belongs here (Fig. 37).

The small bowl (Fig. 38) with what looks like arrow-feather stylization and circlet centerpiece is from Samarkand, probably around the eleventh century. The clear, bold strokes in black around the rim are a Samarkand specialty. This small piece is compact but sturdily made. I was able to gather some shards of this kind at Bamiyan in Afghanistan. But the circular design in the center and the arrow-feather pattern inside are not mere cursive stylization. They seem to be symbols of the evil-eye faith. To escape the devil's curse, one shields oneself with a large eye to return the evil gaze. This belief was once common among primitive tribes, and was especially popular in Persia. To this day when you go to a bazaar in a small town you can see in the shops of silversmiths small evil-eye charms of beaten silver. They are worn around the neck or put in the pocket for protection. Sometimes you find pendants made of real eyes, enough to make one squirm. Just as peacock feathers are flecked with countless eyes but are beautiful and shining, so too, the strong gaze of the eye that fends off evil is symbolic and beautiful. Remnants of this exist in the saving of peacock feathers for decoration. The faith that puts the peacock into pottery patterns is of like feeling.

Another kind of ware we can classify as being from Samarkand is

the large dish in Figure 39 with a bold plant design executed in red and black on white, also containing stylized writing. The glaze is completely nontransparent, as if the dish were bathed in milk. Over this you have a lively red and black, quite a modern combination to say the least. You run across this kind of thing imported from Samarkand, Bukhara, or Afghanistan every now and then among both old and new wares. It brings you something indefinable from the plains of Central Asia.

On another small bowl in three colors (Fig. 40), the design is not carved. You might label it six-petal-pattern pottery. The three colors are not the same as in the Chinese. It features purple. Egypt was fond of purple also. Purple comes, of course, from manganese. It is here lavishly employed along with the blue and green of copper as is the artwork that follows.

The three colors of Persia were used in combination purely for effect. But there are also more than a few spiral and floral designs under the three-color glazing. In the river basin of Bamiyan, famed for its Buddhist ruins, stands the town of Share-Gorgora. In the thirteenth century it was completely leveled before the westward advance of the Mongols. Atop a small hill stands the citadel, the walls and destroyed buildings still to be seen, a silent symbol of eternal death. I went there twice. Each time I was able to pick up some excellent three-color fragments. The superb clay surfaces are slightly tinged with red, and extremely hard. There is a light glaze of white with flower designs inscribed in exquisite three-color transparent glazing. Meandering through the ruins, one even comes across an occasional skeleton scattered about. Charred wood fragments appear here and there. The valley of Bamiyan is always lovely. I saw white birches turn yellow, then brilliant gold, the leaves fluttering off in the wind that whipped through the valley. In October there is already an evening frost.

I ONCE MADE a visit to Nishapur. It was autumn then too. The leaves of the poplars dotting the oasis had all turned. A biting breeze blew and no one was about. Covered with dust from my safari, I sat sipping a cup of tea, aimlessly watching the poplars lose the last of their leaves. Nishapur harbors the grave of the twelfth-century poet Omar Khayyam. There also are ruins that yield a great treasure of Islamic pottery—the precious lifeline for the merchants of Teheran. Here again the Mongols dealt their destruction. But not only here: Ray, Saveh, and Kashan, well-known pottery spots south of Teheran, were also entirely wiped out.

The dish in Figure 41 with the Nishapur bird design is gracefully executed, simply but colorfully, with fine black lines on a buff background. This dovelike representation is a specialty of Nishapur wares. In fact, it is a peacock. The tail feathers are depicted as being bound up behind. Similarly the dish with the bird pattern done in yellow ocher on pale yellow backing (Fig. 42) is probably also a Nishapur product. But it is close in time to the Samarkand-type bird designs touched upon earlier. I picked up pieces exactly like it among the remains at Nishapur. Along with them I also found many fragments of small glass bowls. There were many with stamped ornamentation, glass-filament twining, or edge decoration. The glass from any of them proved on analysis to be of excellent soda composition. Another small bowl with beasts in the four sections instead of birds, and painted in polychrome style (Fig. 43), can most likely be numbered among Nishapur types.

The dish with something like a scattered plum blossom design on black (Fig. 44) is of rare beauty. A bowl with a reversed design—black sprinkled on white, is seen in Figure 12. This is color combination of no little sophistication. Both originated in tenth-century Nishapur. In Ghazni, southern Afghanistan, I managed to get potsherds of similarly colored floral design. Ghazni is a very tired old town. Once you get away from the bazaars, you see two brick

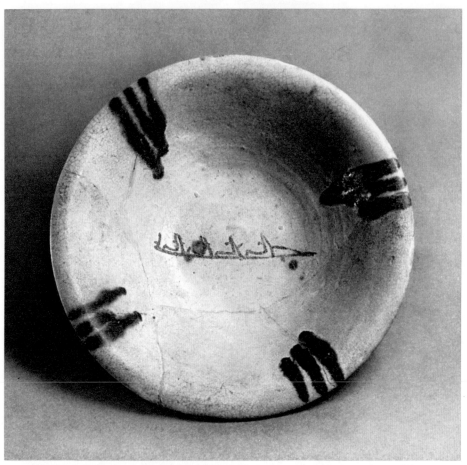

34. White bowl with green design and black calligraphy. Mesopotamia. Tenth century. Height, 5.3 cm.; diameter, 9.1 cm. Tenri Museum, Tenri, Nara Prefecture.

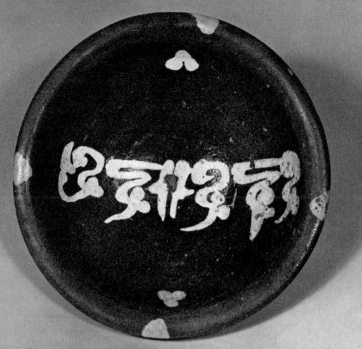

35. Yellowish-brown dish with white calligraphy. Height, 3.7 cm.; diameter, 11.8 cm.

36. Dish with design of black waterfowl on white background. Nishapur. Tenth century. Height, 6 cm.; diameter; 14.5 cm.

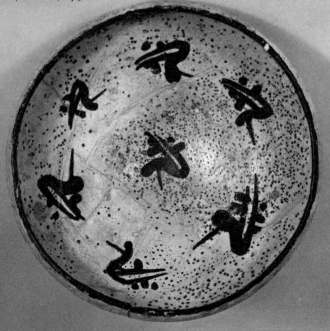

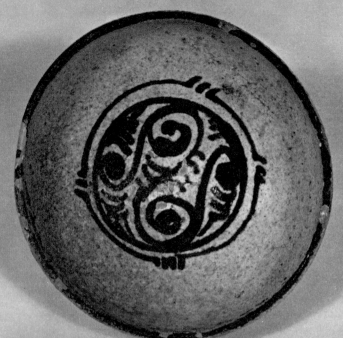

37. Dish with black design of flowering plant on white background. Nishapur. Tenth century. Height, 4.5 cm.; diameter, 10.2 cm.

38. Multicolored bowl with stylized arrow-feather pattern and circlet centerpiece (evil-eye design) on red background. Samarkand. Eleventh century. Height, 5.5 cm.; diameter, 10.5 cm.

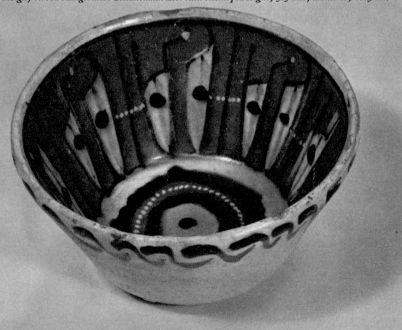

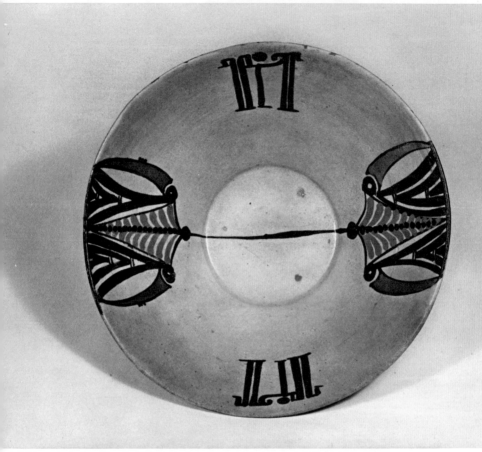

39. Dish with plant design and calligraphy in red and black on white background. Samarkand. Tenth century. Height, 9.2 cm.; diameter, 24.6 cm.

40 (opposite page). Two views of small bowl with six-petal pattern in purple, blue, and green. Nishapur. ▷
Tenth century. Height, 4.9 cm.; diameter, 12.6 cm.

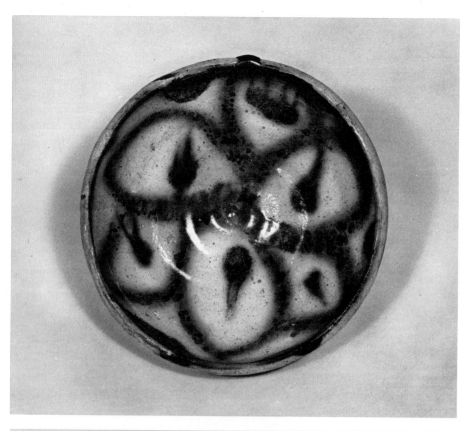

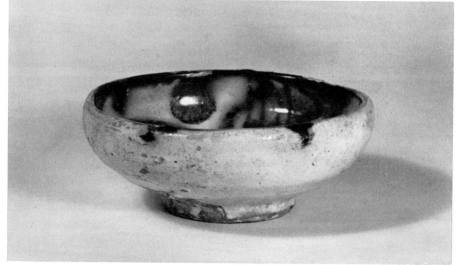

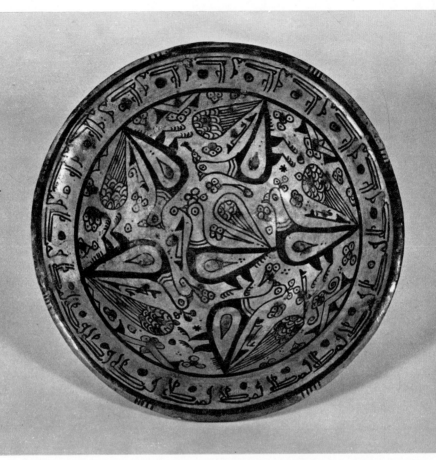

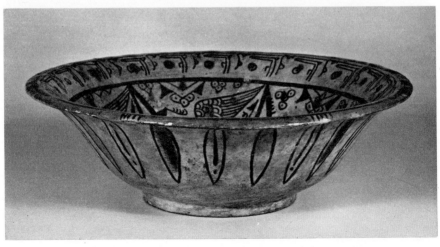

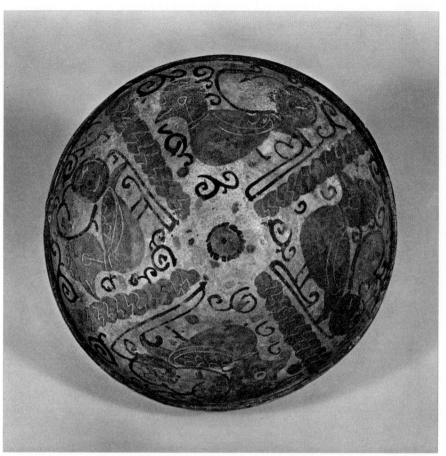

42. *Dish with brownish-green bird design on buff background. Nishapur. Ninth century. Height, 8.5 cm.; diameter, 21.9 cm.*

◁ 41 *(opposite page). Two views of dish with peacock design in colors and black on buff background. Nishapur. Tenth century. Height, 6.9 cm.; diameter, 22.4 cm.*

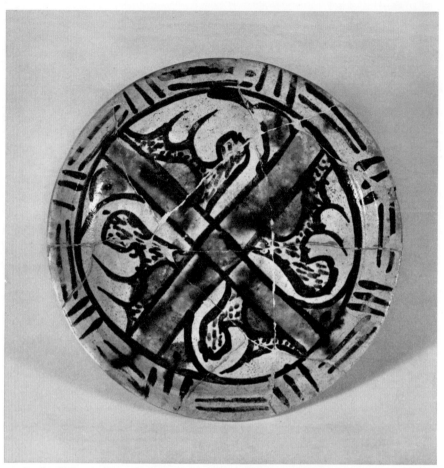

43. Bowl with design of beasts in three colors on white background. Nishapur. Tenth century. Height, 3.8 cm.; diameter, 6.3 cm.

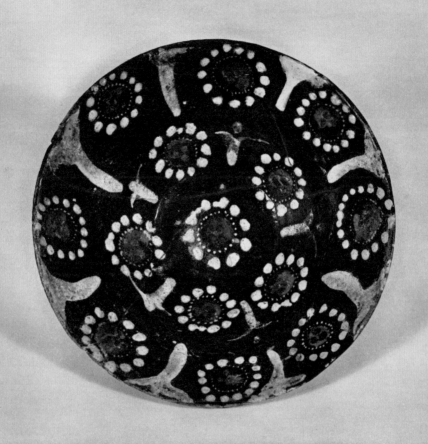

44. Multicolored dish with blossom design on black background. Nishapur. Tenth century. Height, 6.4 cm.; diameter, 21.6 cm.

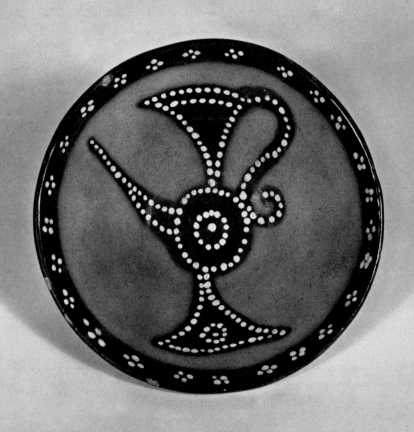

45. *Multicolored dish with ewer design outlined in white dots on gray background. Nishapur. Eleventh century. Height, 4.3 cm.; diameter, 12.6 cm.*

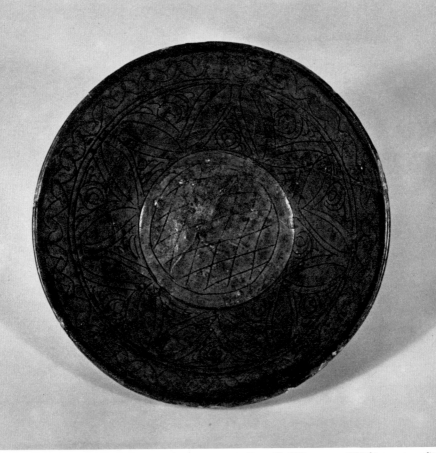

46. Dish with incised floral design under copper-green glaze. Twelfth century. Height, 5.7 cm.; diameter, 19.2 cm.

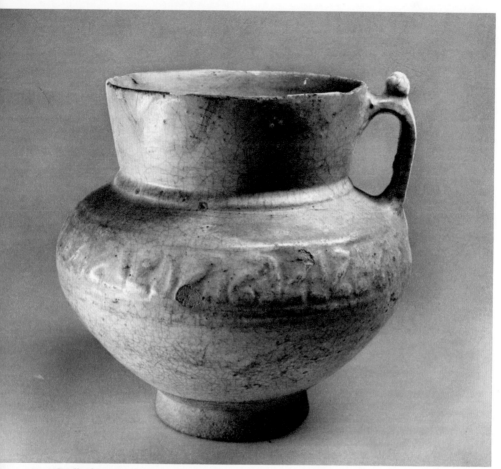

47. Small white-glazed water jug with raised calligraphy on shoulder. Twelfth century. Height, 14.8 cm.; diameter, 16.2 cm. Tenri Museum, Tenri, Nara Prefecture.

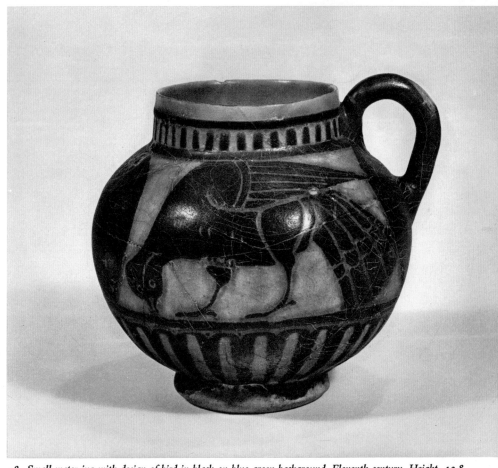

48. Small water jug with design of bird in black on blue-green background. Eleventh century. Height, 12.8 cm.; diameter, 13.6 cm.

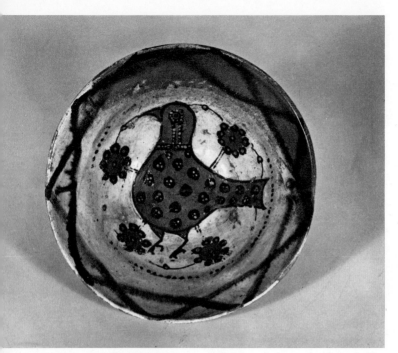

49. Plate with colorful bird design on dark-brown background and interlocking triangles around the rim. Sari. Eleventh century. Height, 5.5 cm.; diameter, 16.5 cm.

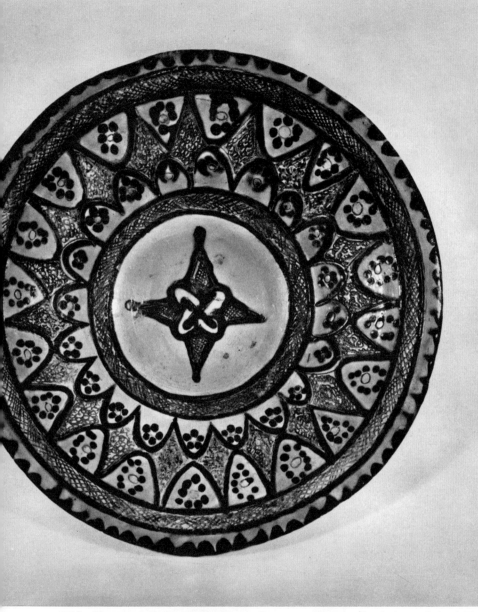

50. Dish with green stipple decoration and entwined-cross centerpiece on yellow background. Amol. Twelfth century. Height, 8 cm.; diameter, 31.2 cm.

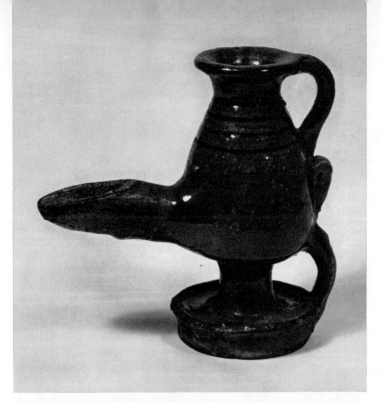

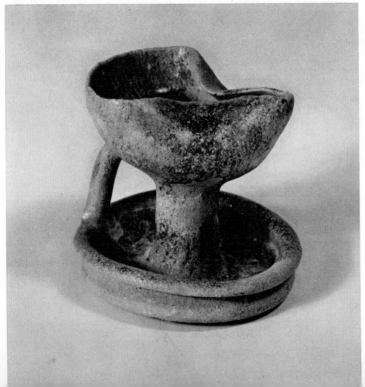

53. Lamp with black iron glaze. Thirteenth century. Height, 33.2 cm. Tenri Museum, Tenri, Nara Prefecture.

◁ *51 (opposite page, top). Lamp with green glaze. Thirteenth century. Height, 15.3 cm.*

◁ *52 (opposite page, bottom). Lamp with blue glaze. Twelfth century. Height, 7.2 cm.*

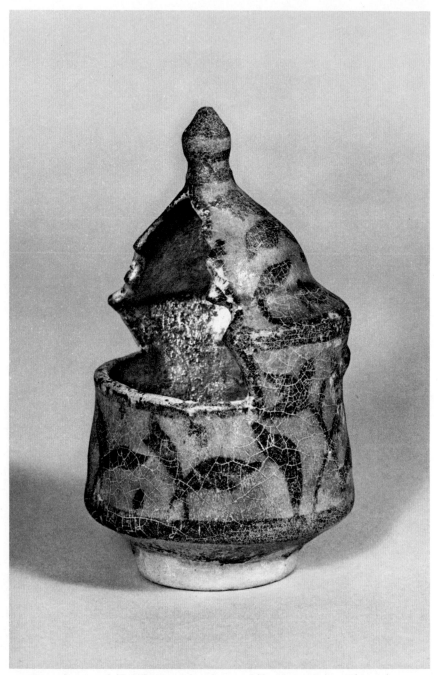

54. Incense burner with black flowering-plant design and blue glaze. Kashan. Thirteenth century. Height, 12.8 cm.

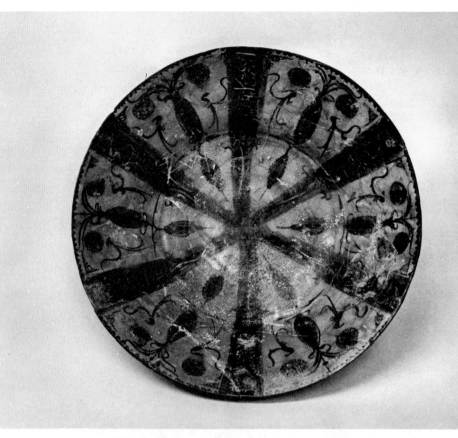

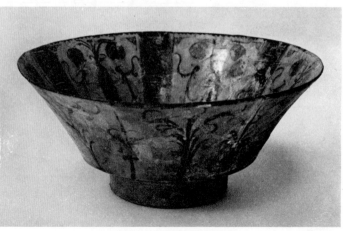

55. *Two views of bowl with black calligraphy and foliage designs under transparent blue glaze. Kashan. Thirteenth century. Height, 8.9 cm.; diameter, 21.9 cm. Tenri Museum, Tenri, Nara Prefecture.*

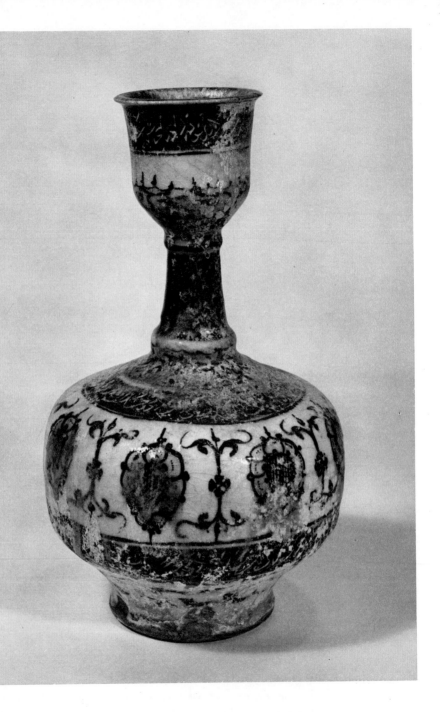

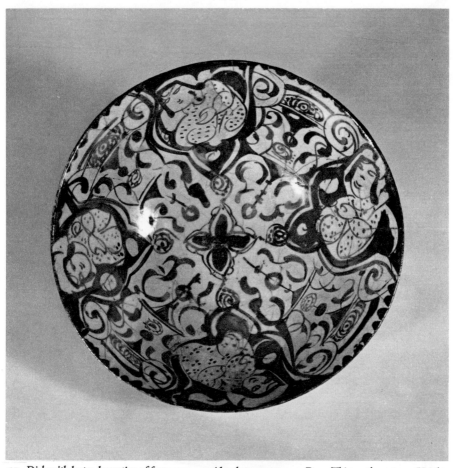

57. *Dish with luster decoration of four women amidst abstract patterns. Ray. Thirteenth century. Height, 7.2 cm.; diameter, 20.3 cm. Itsuo Art Museum, Ikeda, Osaka Prefecture.*

◁ 56 (opposite page). *Bottle with copper-green plant design on white background under transparent glaze. Kashan. Thirteenth century. Height, 25.3 cm.; widest diameter, 14.8 cm.*

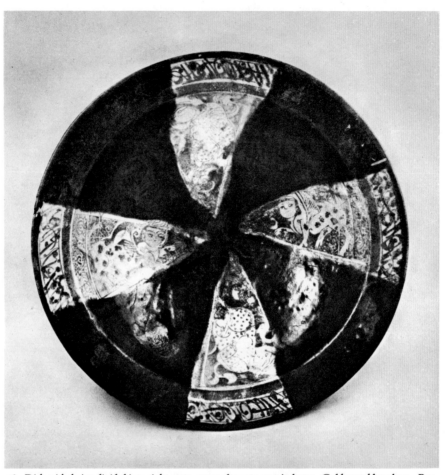

*58. Dish with design divided into eight parts, every alternate part in luster. Gold over blue glaze. Ray.
Thirteenth century. Height, 9.2 cm.; diameter, 36.4 cm. Itsuo Art Museum, Ikeda, Osaka Prefecture.*

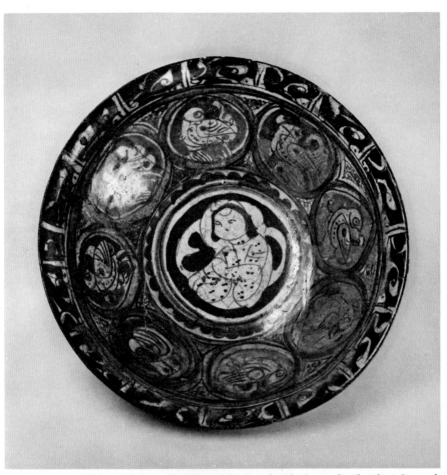

59. *Luster-painted dish with figure in the center and the inner shoulder decorated with eight circlets, each enclosing a bird. Ray. Thirteenth century. Height, 8.5 cm.; diameter, 19.5 cm. Tenri Museum, Tenri, Nara Prefecture.*

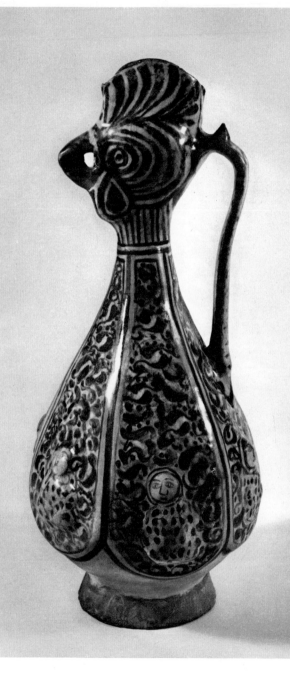

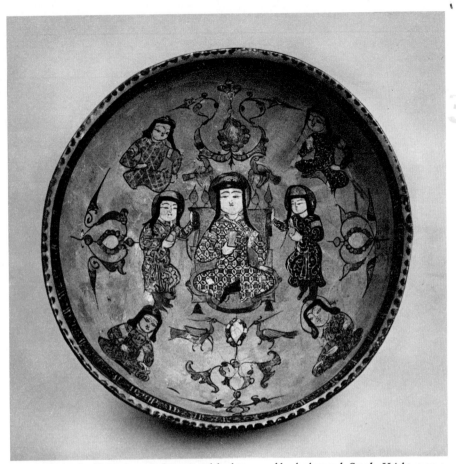

61. Minai bowl with king's-court design in subdued tones on blue background. Saveh. Height, 9 cm.; diameter, 18.5 cm.

◁ 60 (opposite page). Cock's-head pitcher with luster designs of men on profusely decorated sides. Sultanabad. Thirteenth century. Height, 36.2 cm. Itsuo Art Museum, Ikeda, Osaka Prefecture.

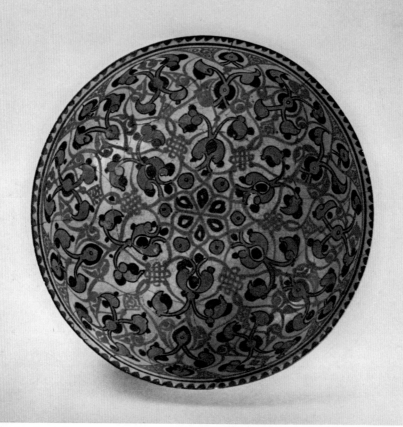

62. Minai *bowl with flower-and-vine design on white background. Saveh. Height, 8.3 cm.; diameter, 21.6* cm. Tenri Museum, Tenri, Nara Prefecture.

63 (opposite page). *Two views of* minai *bowl with design of four horsemen on the inside, and calligraphy on* ▷ both the inside and outside rims. Ray. Height, 9.5 cm.; diameter, 20.5 cm.

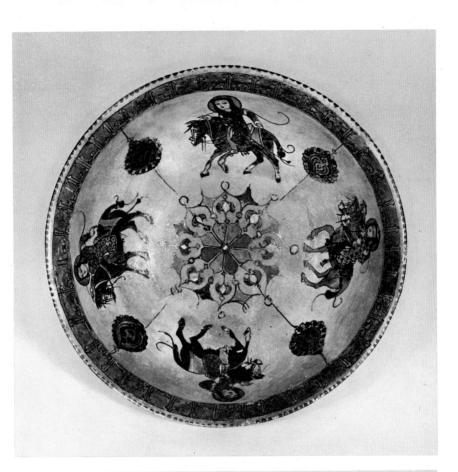

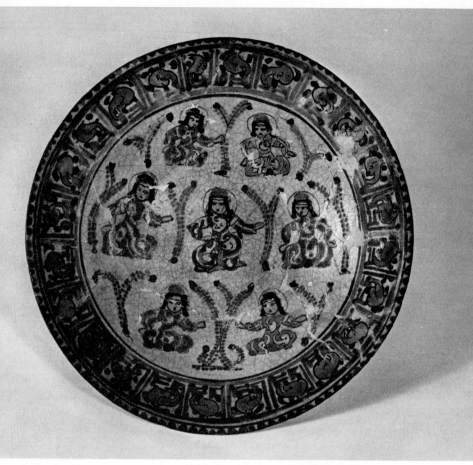

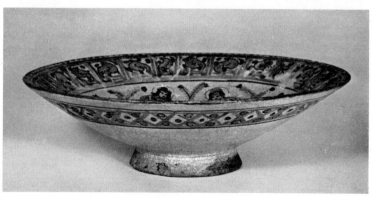

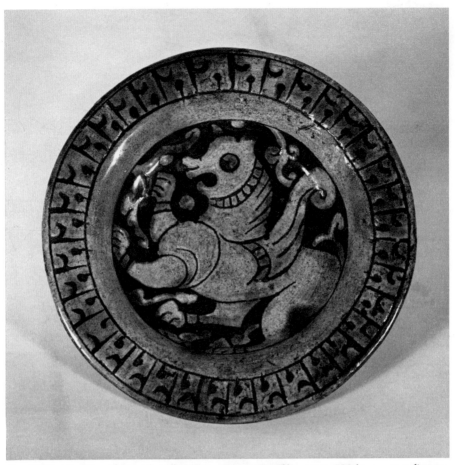

65. Gabri-style dish with carved griffin design. Garus. Twelfth century. Height, 2.4 cm.; diameter, 14.3 cm.

◁ *64. (opposite page). Two views of minai dish with white background and design of men and women sitting under trees. Saveh. Height, 6.3 cm.; diameter, 22.3 cm. Ohara Art Museum, Kurashiki, Okayama Prefecture.*

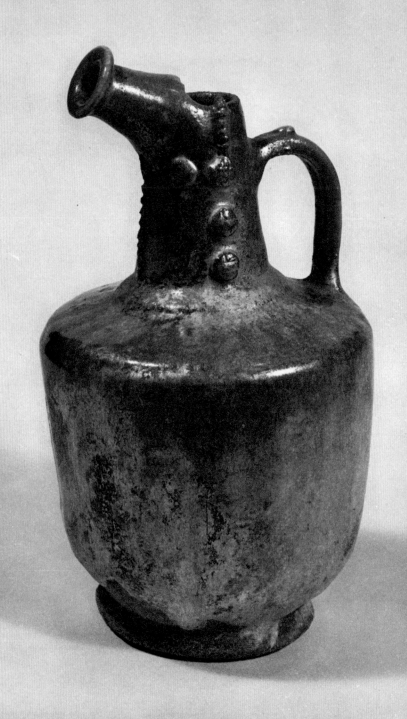

66. *Ewer with turquoise glaze. Kashan. Thirteenth century. Height, 15.5 cm.; diameter, 9.2 cm.*

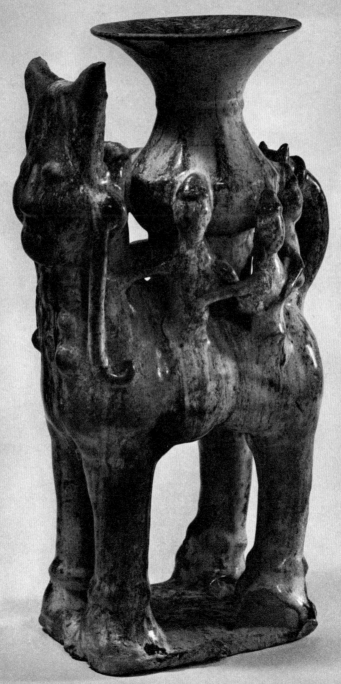

67. *Turquoise-glazed horse figurine with large water jar supported by tiny men. Kashan. Thirteenth century. Height, 30.1 cm.*

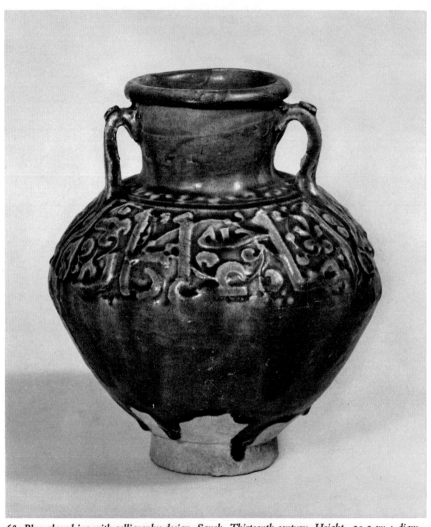

68. Blue-glazed jug with calligraphy design. Saveh. Thirteenth century. Height, 23.2 cm.; diameter, 20 cm.

69 (opposite page). Large four-handled jug with blue glaze. Saveh. Thirteenth century. Height, ▷ 44.3 cm.; diameter, 30.5 cm.

70. *Cup with vertical green lines on white background. Kashan. Thirteenth century. Height, 9.8 cm.; diameter at mouth, 6.3 cm.*

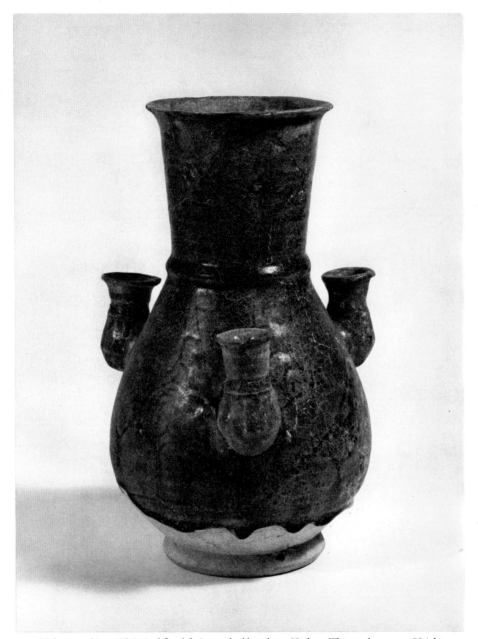

71. *Multispouted jug with incised floral design under blue glaze. Kashan. Thirteenth century. Height, 22.3 cm.; diameter at mouth, 9.1 cm. Ohara Art Museum, Kurashiki, Okayama Prefecture.*

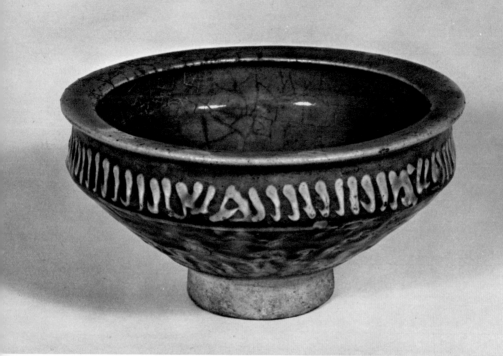

72. *Broad-lipped bowl with white script design under turquoise glaze. Kashan. Thirteenth century. Height,
10.3 cm.; diameter, 20.5 cm. Ohara Art Museum, Kurashiki, Okayama Prefecture.*

73 (opposite page). *Bottle with overall floral and spiral designs in gold with blue glaze. Sultanabad. Four-* ▷
teenth century. Height, 31.5 cm.; diameter, 16.5 cm. Ohara Art Museum, Kurashiki, Okayama Prefecture.

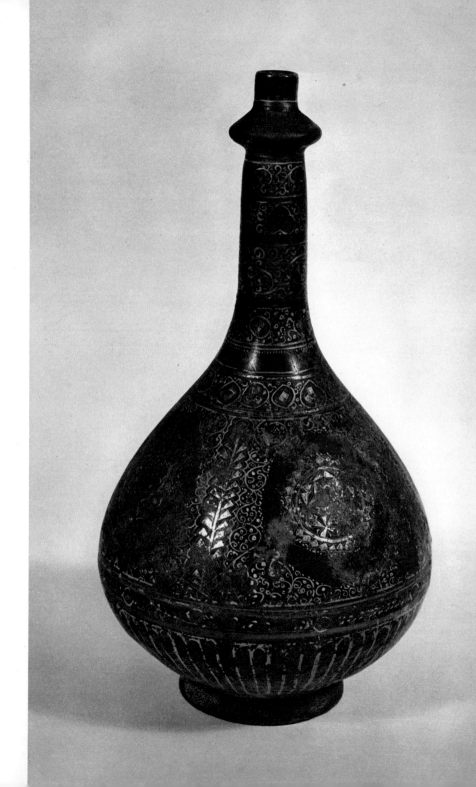

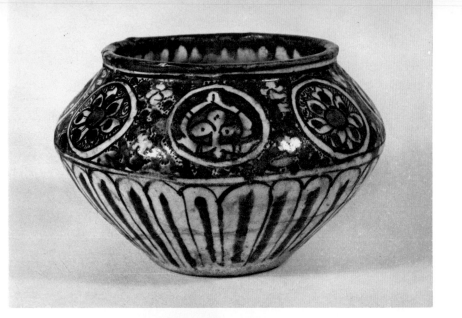

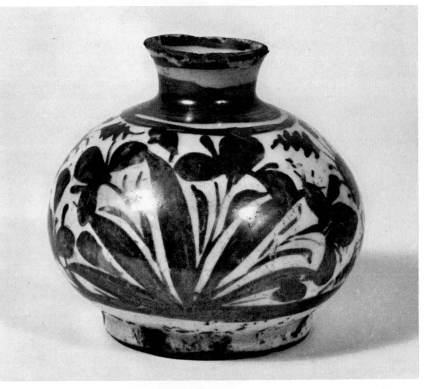

76. Multicolored bowl with flower-and-bird design. Eighteenth century. Height, 11.6 cm.; diameter, 20.6 cm.

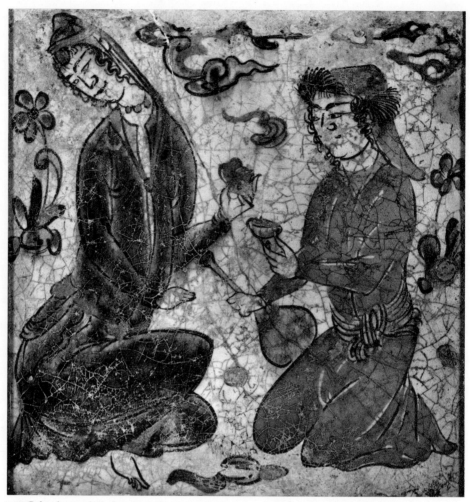

77. Color-decorated tile from Kubachi. Seventeenth century. Length, 18.5 cm.; width, 17.7 cm.

78. Color-decorated tile from Kubachi. Seventeenth century. Length, 17.6 cm.; width, 17.6 cm.

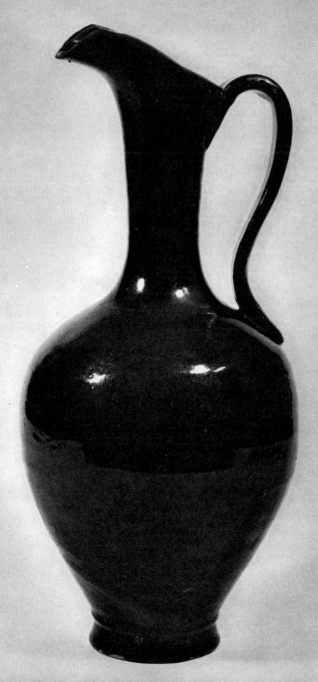

79. Water pitcher with black glaze. Yazd. Twentieth century. Height, 33.7 cm.; diameter, 15.1 cm.

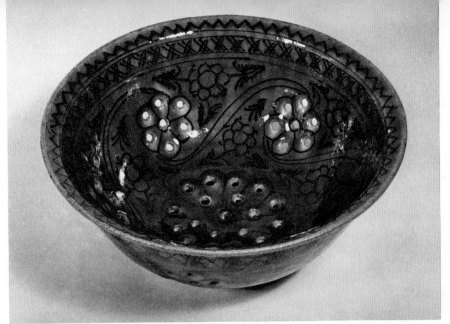

80. *Bowl with floral decoration and firefly design. Twentieth century. Height, 9.9 cm.; diameter, 22.8. cm.*

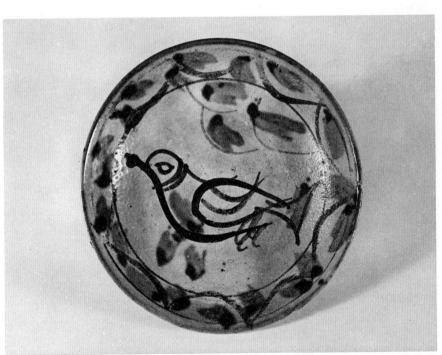

81. *Dish with three-colored bird design. Rareijin. Twentieth century. Height, 4.4 cm.; diameter, 18.4 cm.*

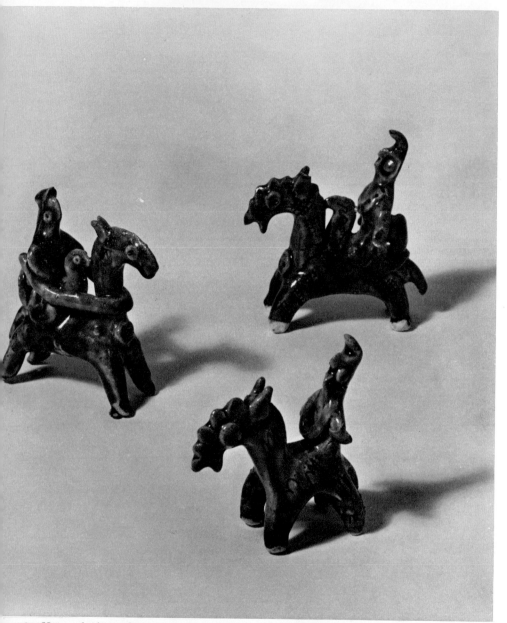

82. Horse–and–rider toy figurines. Istalif, Afghanistan. Twentieth century. Average height, 10.5 cm.

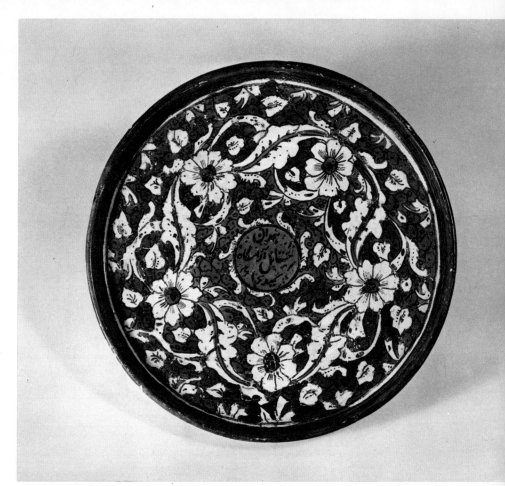

83. Plate with floral design, calligraphy in the center, and turquoise glaze. Rareijin. Twentieth century. Height, 2.7 cm.; diameter, 25.5 cm.

85. Modern tile from Isfahan. Length, 15.3 cm.; width, 15.3 cm.

◁ *84 (opposite page). Water pitcher with turquoise glaze. Rareijin. Twentieth century. Height, 35 cm.; diameter, 13.1 cm.*

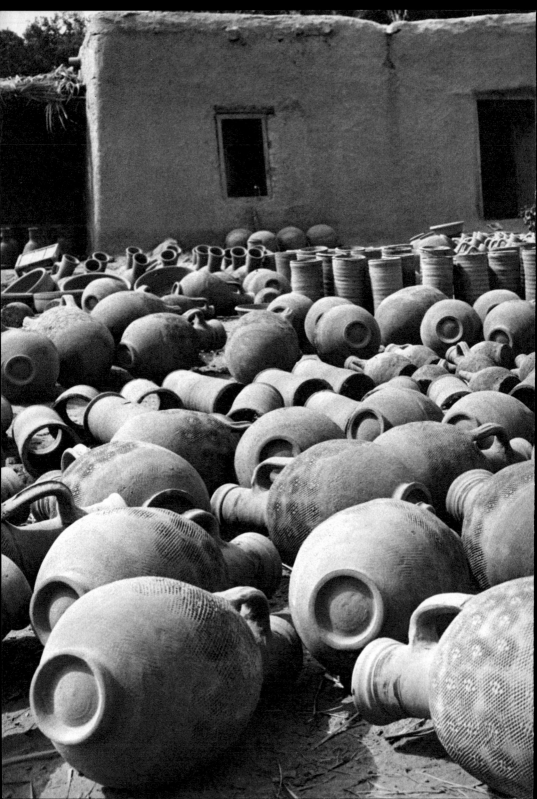

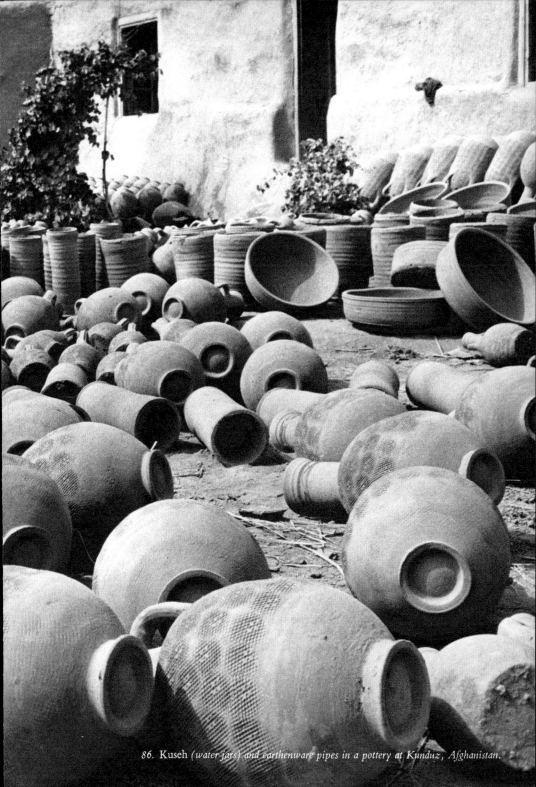

86. Kuseh *(water-jars)* and earthenware pipes in a pottery at Kunduz, Afghanistan.

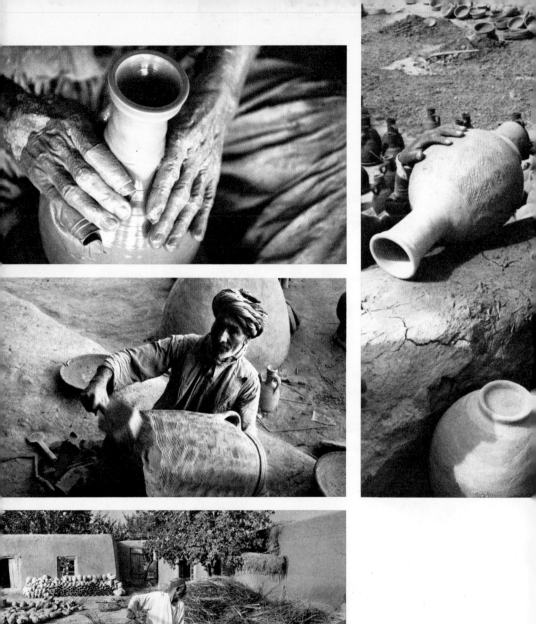

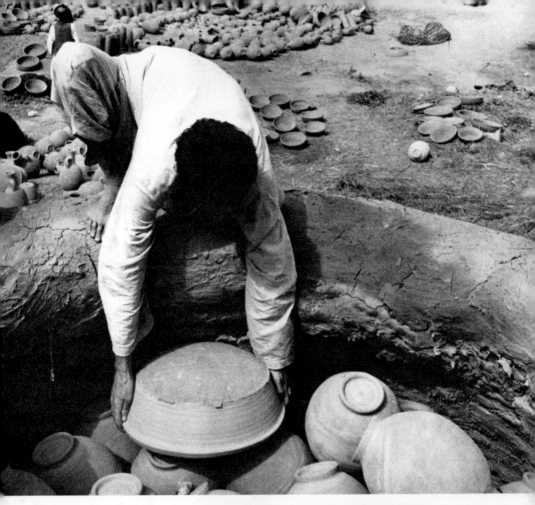

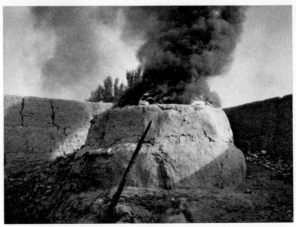

87–91. Water-jar pottery at Kunduz: (87, upper left) a potter shaping a water jar on the wheel; (88, left center) one of the larger water jars is slapped into shape with a paddle-shaped piece of wood; (89, bottom left) dried reeds used as fuel for the kiln; (90, upper right) stacking the kiln with earthenware bowls; (91, bottom right) the kiln being fired.

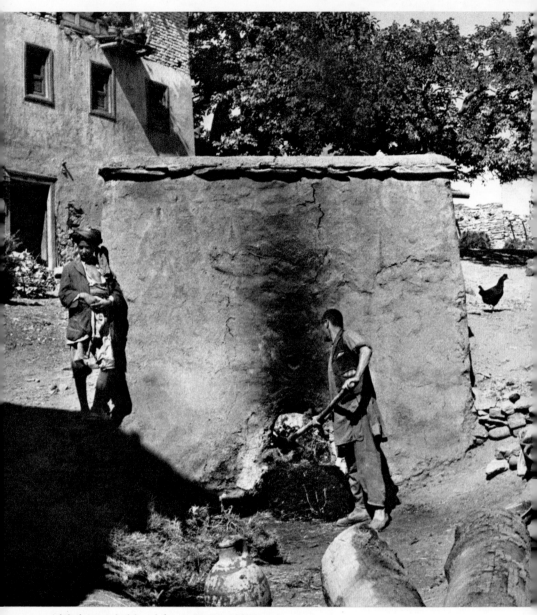

92. *A kiln being stoked from below in Istalif, Afghanistan.*

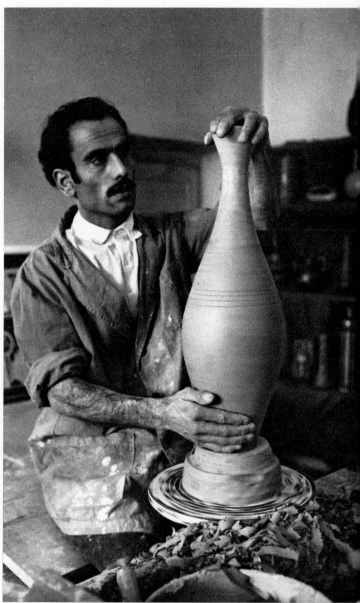

93. *A Teheran potter at work.*

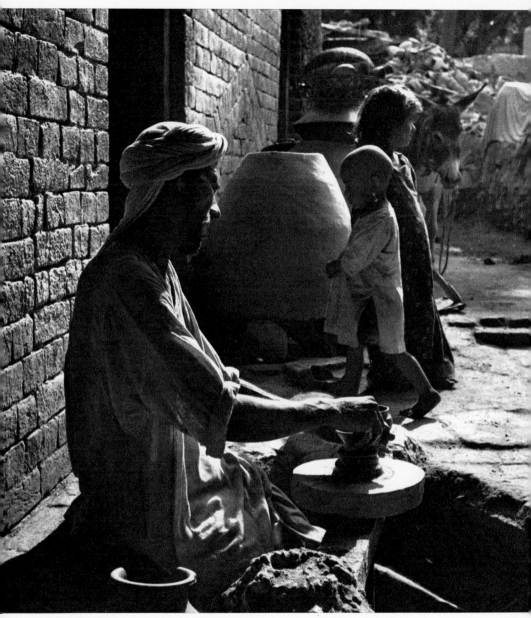

94. *A Multan potter shaping a small bowl on the wheel.*

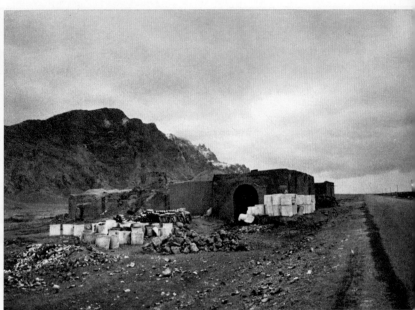

95. *Rural pottery at Shareza.*

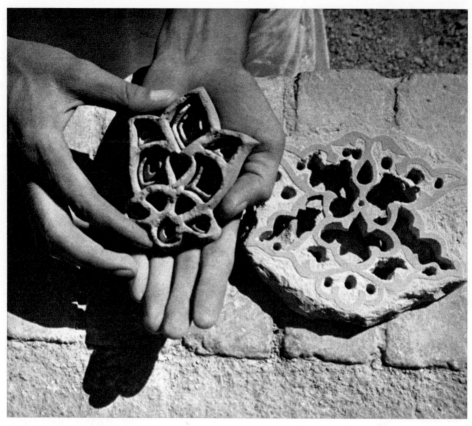

96. An intricate tile form in the shape of a flower head.

towers with rather complex mosaic designs on the side. This is where the eleventh-century Ghazni kings held sway. The towers commemorate them. The remains yielded three-color fragments of carved design. There were also pieces with three-color glazing, all of them of Islamic variety. Other shards were of glazed white background, sprinkled generously with dots of copper green and dark, ironish brown. I discovered some with black backgrounds and lighter brown small circles ringed daintily with dots. In the museum of Kabul the real thing is extant in one piece. The deep shades of black are no less than exquisite. On a chilly day when no one was there, I found myself loitering around in front of it, in admiration. Another memory of Ghazni is of the fragments of Sung celadon from China that I found there.

The bowl in Figure 11, showing a soldier and horse in stipple style, is another special Nishapur technique. The figures are in red and black on a cream background, with the glaze stippled on for overall effect. The rim is decorated with calligraphy. Examples of this man-and-horse pattern are many. Early lusterware dishes had it. The design is indubitably Sassanian. The royal hunt is embossed on silver vessels: the king, astride a galloping steed, draws his bow, taking up all the space on the dish. The feeling is reminiscent of Abbasid times. The same technique, white dots on a quiet gray background, can be seen on the dish with the ewerlike shape and handle in Figure 45. The design is well worn, so the dish might possibly be placed a little earlier. The original symmetrical floral rendering has been altered.

Wares of multicolor and single-color glazes were made at the same time. A large, many-flowered pattern incised under copper-green glaze is exemplified in Figure 46. The feeling of depth exuded by the green background is found frequently on wares from this locale. Fragments are easily gathered in ruins hereabouts. There are also pieces, such as the small water jug in Figure 47, that are glazed completely in white with raised calligraphy on the shoulder. The vessel

here is thought to be of about tenth-century vintage. But I would rather place it around the twelfth century, since water pitchers of this shape were not yet in circulation in the tenth century. At the very earliest, call it eleventh century. The techniques for raising work on pottery with white glazing did not begin with Abbasid times.

Abbasid-period small vase work is of the form seen in Figure 48. The black bird, pecking feed, on a blue-green background, is fascinating. Note that two eyes are drawn in—we could say it is the earliest sign of Picasso-like cubism. The expression is fairly adept. There are also pieces with a horse's eyes rendered in the same style. Both the shape and the artwork on this vase are exceptionally well done; it is a work of art.

ABOUT THIS TIME there were kilns at Sari and Amol in the Mazanderan district along the Caspian. You can tell Sari work at a glance (Fig. 4). A large bird is drawn in the middle, ringed by floral designs or circlets. Both bird and pattern are decorated in bright red, black, yellow, and green. The stipple work is common to Nishapur. The eyes of these birds are large. Needless to say, this is again a carryover from the evil-eye cult we noted earlier. The circles and flowers here and there around the shoulder are also related to the eye imagery. The bird is a peacock. The plate of Figure 49, with a bird in the center framed with interlocking triangles, is unusual. The bird here could be a dove.

Amol is known for incised patterns. The decorating is in stipple under an overglaze of brown or green. The large dish in Figure 50 with an entwined-cross centerpiece is typical of Amol. Date it about the twelfth century. Pieces fired in such kilns are solid and show a clean line. Amol craftsmanship is meticulous.

Again, in Amol work, we notice bird designs, but find them different from those of Sari in that they closely approximate the dove. Be they waterfowl or peacock, the birds are obviously descendants of

Sassanian or prehistoric times. But what fixed the peacock tradition was Byzantine influence. Eastern Christianity venerated the symbolic. The peacock symbolized immortality and the dove stood for the soul or the Holy Ghost. I suspect the evil-eye cult and the folk beliefs of birds or spirits were reinforced by this. And Islamic flair for decorative writing might well be laid at the door of Byzantium, too. The latter loved calligraphic combinations. It was a fusion of theology and aesthetics.

Amol. It was another dark, drizzly day when I went there. The town was lonely and desolate and the streets a quagmire that made passage almost impossible. The Haraz River has overflowed its banks many times. Each time, a new town was built upon the old foundations. They say that people dig up bricks buried in the river bottom to erect their homes anew. A traveler's tale has it that the queen's jewels, swept away in a torrent, attracted a host of fortune diggers.

A mosque, which houses a mausoleum, stands in this town of gray skies. It is of wood. The walls of the mosque are decorated in eighteenth-century Persian-style paintings done in yellow and blue. The local bricks are fired red. People in the arid zones to the south use bricks that are sun-dried. Here they must be fired because of the rains. The town, a grove of lush green, gets incessant rain.

ABOUT THE MIDDLE of the eleventh century, the Seljuks of Turkey (1037–1231) took over in Persia. Ray was made the capital. The sultans fought the Abbasid powers centered in Baghdad. Persia, true to the Turkish name it bore then, fell once more under the spell of the West.

Ray is a small city south of Teheran where reminders of Seljuk days abound. The fountain of Ali, still gushing crystal water in great abundance, is one. Behind is a small rise of rock at the base of a mountain. At the fountain, rugs from Teheran are cleaned—Persian carpets with the dazzling hues of a flower garden. First washed in the

spring, they are then spread out on stones to dry in the summer sun. It was a bouquet of flowers, and the waters of the spring were of the clearest blue.

On top of the rocky mountain stood a crumbling fort. It formed a part of the ancient fortress of Ray, completely vanquished in the Mongol march of the thirteenth century and never since restored. Beside it I gathered some large glass fragments. The exteriors are hard and glitter with rainbowlike colors. The silvered surfaces flake off like butterfly wings. Purple, blue, brown—any way you turn them in the light, they sensitively glow a different color. Unbelievably beautiful, this ancient glass. I analyzed it: the fragments divulged soda glass, and the fine silver-plated surface could be peeled off in layers, allowing me to perform spectrum analysis. The calcium content beneath was as low as that on the surface. So each layer was changing composition as the calcium dissolved. Then it struck me: the calcium was removed while the glass was buried in the earth.

ANOTHER CITY, like Ray close to Teheran, had many remains from the Ilkhan dynasty (1227-1336), successor of the Seljuks. This was Varamin. Still left are a mosque that is falling apart, entirely leveled ramparts, and a huge building. The tiles of the mosque are a gorgeous blue—and at dusk an unforgettable purple (Fig. 14). I gathered Islamic shards in abundance at one ruin there. There were many thick, outsize pieces and much underglaze decoration. Most bore abstract patterns, lattice designs, perpendicular lines using a manganese-base purple. There were transparent glazes on blue, white, or turquoise; the background again was of purple or copper blue. Colors were generally blocked off into fourths. The provenance is said to be Ray or Kashan. I could not find a single shard with black floral design in turquoise under transparent glazing. The pieces heavily colored with manganese were completely different from Ray work; possibly they are from Varamin.

IN ISLAMIC POTTERY you find many lamps. Figures 51 and 52 show simple work glazed in blue and green. Somewhat more intricate is the lamp of Figure 53 done in black iron glaze. This type is rare.

Pottery featuring transparent turquoise glazing over delicate designs of black brushwork in Chinese, flowering plant, or arabesque style is very common among Persian wares. It affords a simple but beautiful pottery (Fig. 54). Fragments of it can be picked up at almost any ancient site. There is no doubt it was a popular item made in great quantities. What immediately comes to my mind when I see them, is blue-and-white pottery: the Chinese ware is blue and white, the Islamic ware is black and blue. Though the colors are different, still somehow they strike a common chord. Am I just imagining it, or is there a real relationship? The fact remains that fragments are found in ruined Chinese cities of the Yuan dynasty. Was such pottery made in China? Is it an import from the West? We will come back to this problem of provenance on page 143.

Over and above these, you often see techniques where blue and black glazing is applied so as to flow out from the center of a piece. The bowl in Figure 55 contains writing and foliage designs, both under a thick, transparent glaze. This is quite an improvement over the blue glaze and black design on the incense burner in Figure 54. It probably comes from Kashan.

Lusterware once more came to the fore during the period. It was an old favorite in Egypt and Syria. Flora, fauna, and spiral designs —all were executed with a deft, freehand brush. But in Persia it did not fare so well, not catching on there until the eleventh century. With the start of the twelfth century, things took a sudden turn; the influence of potters of Turkish descent quite likely came into play. The feel of lusterware is decidedly metallic. And the reason it flourished in the twelfth century, according to some sources, is because of the sudden lifting of the proscription on gold and silver vessels that had begun in Abbasid times. But this cannot be the actual case, for

the court nobility freely used gold and silver vessels. Simpler reasons for lusterware's popularity are that it was moderately priced and its metallic properties were appealling. Also, at Meshed, in eastern Iran, there is a tile that has been decorated with luster and inscribed with the date 1118.

The vessel in Figure 8 is entirely incised with typically Islamic designs. It is stunning. Many vessels of this shape were made at this time. This one is most likely a drinking cup. The bottle with the copper floral design and transparent glaze over (Fig. 56) is another example. The copper green is blurred slightly, a beautiful effect. Miniature paintings often show women-in-waiting serving from such jugs.

The dish with the four figures around the inside (Fig. 57) is quite interesting. The eyes and eyebrows are set apart and the noses barely suggested. This is indicative of the Ray school. Another work of the same school (Fig. 58) finds the whole divided into eight parts, every alternate part in luster; gold is used over blue glaze. It is approximately thirteenth century. The figures stand out in burnished gold which, sprinkled on deep blue glaze, evokes a singularly rich feeling. The design in Figure 59, the center with a figure and the inner shoulder decorated with eight circlets each enclosing a bird, is quite rare. The play of circlets in a design had been in use since the silver vessels of the Sassanians, but there were few designs that combined people and birds. There are instead many vessels depicting a human figure in the center surrounded by the twelve heavenly constellations. It was commonly thought that the stars preside over man's destiny.

The bird-and-man combination comes to mind in the cock's-head pitcher of Figure 60. The shape has many companions. It is also a successor to the shapes of the silver water jugs of the Sassanid period, now having evolved into the form of a bird. Once again you have figures on the sides. Are we confronted here with Sultanabad script?

As might be thought, the bird again represents the human soul. On the dishes and bowls alike one can still make out the incantations.

POTTERY IN ISLAMIC art reached its flowering with *minai* ware. It enjoyed but a brief period of production, only about a hundred years from the mid-twelfth to the mid-thirteenth century. Its time was short but it bloomed brightly before fading. "Minai" means to paint with enamel. Even now copper or porcelain vessels covered with white glass glaze, painted with enamel, and fired, are very popular. In ancient Persian, however, the word means simply glass. This is understandable since it is actually an application of color-painted glass techniques to pottery. Syria was the center of this kind of thing. Enamel is made at a low melting point with oxidized lead as a solvent, and iron, manganese, tin, copper, and the like are used for color. The lamps decorating the interiors of mosques have enameled glass on the outside that gives off an exotic glow.

It was the enamel firing technique and the miniature painting unique to Persia that gave birth to *minai* ware. The vessel of Figure 8 is a frequent form of it. The designs of animals and flowers in alternating colors is quite extraordinary. The colors of *minai* ware were fixed at seven. Pope enumerates fifteen, but according to the modern method of counting, seven colors is the rule. The artist apparently made miniatures his model: countless miniatures and *minai* remain whose precise resemblence bears this out.

The pattern on the *minai* bowl in Figure 61 is of a standard sort with the retinue to the right and left of the king, who is sitting on his throne, and birds are playing about. This kind of composition is often seen. It is also found on the silver wares of Sassanian make, and on what is called Byzantine. The positioning of the king front and center and handling what is to either side symmetrically is a traditional technique. The blue background, with the whole in subdued tones like the old miniatures, evinces a classic style.

This style of brushwork and design is from Saveh, a town southeast of Teheran. Even now the pottery industry flourishes there. And there are numerous historic remains in the region that long ago became popular places for plundering. One arrives only to find the site gouged with hole after hole. They say one can no longer even come up with fragments of *minai* or lusterware.

In place of figured work are bowls done completely in floral and spiral designs (Fig. 62). The background is white. The technique that fashions floral designs out of a six-petaled flower very probably came from the hands of a Saveh craftsman. The Ray school is said to have turned out similar compositions of concentric circles in this manner.

Wares with horsemen in the center are common too. Figure 7 shows this kind. Rich blue on a cream backing exudes a quiet air. This is also Ray work. The large bowl with four horsemen (Fig. 63), another Ray piece, reveals a theme that is stock-in-trade with *minai*. The horsemen are plainly of noble stripe and are riding about, hunting, or fighting. This is again a motif seen since Sassanian times.

Figure 64 illustrates another typical *minia* composition. A tree is drawn between a man and a woman who sit on either side: lovers sitting quietly to speak of their affection, the blue sky above, and the tree offering shade. It is a charming scene, evidently the most beloved of all. Sassanian influence figures here again by way of the animals or birds of good omen on either side of the tree of life, or the emperor and empress filling and exchanging cups. Bowls like this one, showing people under shady trees, abound. The way of talking with the hands extended is a conversational gesture still indulged in by present-day Persians; the arm-waving and body movement is well caught. Here one finds the exact opposite of the hushed look other couples exhibit beneath their shade trees. The background is white. The artwork is most likely from Saveh, the stipple giving its origin away. The shoulder has a combination script design.

There is a griffin on the small dish in Figure 65. This is what is called Gabri work, from Garus in northwest Iran. Nearly all works of this type have a large lion carved out in the center or a mysterious bird, another throwback from the Sassanians. In Japan, we call this technique *kaki-otoshi*. Two different color glazes are applied. The design results from scraping away the upper glaze, leaving the lower to stand out in sharp contrast after firing. This gives a feeling of strength. The purpose is to impart the damascene effect of metal wares. The many superb pieces of the Sung dynasty in China, executed in two-color flower patterns in black and white, are well known. The definite, carved, metallic effect of the design trim in this piece comes out well.

BLUE, THE COLOR OF turquoise, was another ideal in Persian pottery. Figure 66 shows a beautiful turquoise-blue ewer. It is quite certainly from Kashan. Also glazed in like hue is the slightly odd but sturdy figurine of Figure 67; the men atop the horse are raising a jar. The figurine is thirteenth century, probably from Kashan, too. The blue-glazed Saveh jug (Fig. 68) done in embossed spiral design with calligraphy on it is a perfectly balanced form, the work of an expert craftsman. The large, patternless jug with the four handles (Fig. 69) is of Saveh. More striking (also probably from Kashan) is the cup of Figure 70 with faintly traced, vertical green lines on a white background. The line treatment is disciplined, and the handle is positioned just right. Persian ware in general is marked by myriad designs and stolid shapes, but this one stands out for its fine form. The multispouted jug with the floral design on the sides (Fig. 71) is also seen often in Persian pottery. Look for it in Chinese and Japanese earthenware anywhere from the Kofun period (250–552) up to the Heian period (794–1185). In Japan, however, the jugs have spouts that do not lead into the main vessel, being merely decorative, whereas the spouts on Persian vessels always had openings into the

main part of the vessels. The Persian style is the exception since West Asia, China, and Japan are linked by the other type.

Exquisitely done in turquoise glaze is the broad-lipped bowl of Figure 72. A script pattern is painted on white with choice kaolin. Over it goes turquoise glaze, the kaolin just peeking through for an elegance of expression. This is certainly one of the masterpieces of the Seljuk period. Thus far, this technique has been ascribed to the Ilkhan times that followed the Seljuks and to the influence of China. However, I found shards of pottery made with this technique in the ruins of Share-Gorgora at Bamiyan. As I mentioned before, Share-Gorgora was sacked by the Mongols in the thirteenth century and remains desolate to this day. Up until the Mongol invasion, pottery made by this special technique had journeyed as far as Afghanistan.

THE MONGOL FURY lashed at every part of Persia. In 1258, the Ilkhan empire had taken root, reinforcing the Mongol reign. The Mongols respected Persian culture, but with the destruction of the pottery centers at Nishapur, Ray, Saveh, and Kashan, the history of Persian pottery reached a watershed. From here it would fall into decay. New factors, introduced from China, came in to alter its course. China loomed large on the Persian horizon and not simply because of the Silk Road.

The bottle of Figure 73, glazed in blue and completely covered with gold designs, has a serenity all of its own. Besides gold there appear white and red glazes. The line work on the body is distinctly Chinese. The blue is identical with that on the Sultanabad mosque tiles. Mosques were the prize edifices of the Ilkhans. Lavish wall paintings and golden tiles remain to this day. The same luxurious touch is evident on the small bowl with the blue-glazed flower design in Figure 74. It could very well be Sultanabad in origin. The seven-petaled flowers and cruciform pattern in the circle between the two suggest Western design.

The large plate in Figure 10, with the gold centerpiece of birds with entwined necks and seven birds fluttering around the inner shoulder, is done in gold over blue-green glaze. The treatment is fine, exacting. An intertwining-bird theme was early added to tradition, employed especially in wall decor. It is a variation of the motif in which two birds are positioned on either side of the tree of life. What is exceptional with this piece is the division of the rim into seven sections. It has few parallels as a style. It might just be derived from the West. At any rate it is Sultanabad, around the fourteenth century. A magnificent example of a similar technique of applying gold over a blue-green glaze is to be seen in the flasks of Figure 6.

In the years that followed, Islamic Ilkhan pottery, having reached its zenith, began to fade. Abbas the Great (1587–1629), shah of the Safavid dynasty (1502–1736), tried to resurrect the pottery-making techniques the Persians had learned from China. Pottery with red underglaze designs, similar to the blue-and-white manner, was produced, as well as white porcelain in imitation of Chinese ware. An example of this is the neolusterware vase in Figure 75. The white is always pure and the luster has red over garnet. The flower patterning is obviously Chinese brush style. This may be from Isfahan, around the seventeenth century. The bowl of Figure 76, richly decorated with flowers and birds, belongs to the eighteenth or nineteenth century—the Kajar era. The combinations of red and green reflect the inroads of Western influence.

THE ISLAMIC WORLD spread to Spain and Southeast Asia. Wherever it ventured, the center of its life, a mosque, was erected. The mosque, a building after all, took on the tone of wherever it happened to be. In Persia it was of brick. The outside and inside walls were beautifully tiled or decorated with unglazed brick in varying combinations. Tiles should not be omitted from this discussion, as they form an important part of Persian pottery. When crossing the desert,

what breaks the monotonous yellow horizon is the outline of the oasis. And the first thing you see is the white mud-brick buildings of the village, and then among them the sparkling dome. Seeing it shining there in yellow, blue, and sometimes gold, the traveler is reassured—he is home. In the harsh heat of the dry desert the sight of it revives the spirit like nothing else.

White pigeons flutter around the blue tiles of the mosque dome located in the northeastern province of Balkh, in Afghanistan (Fig. 15). This is a Herat-style work dating from the reign of Tamerlane (c. 1385–1405) who held sway in Central Asia. Present pilgrims to this spot are few, and they come only to sing a lamentation or two before they travel on. A wall design with trim cedars and flowers against white (Fig. 16) was seen on a small building at Lahore, the ancient capital of Pakistan. This area lived continually under the spell of Persian culture. There are many buildings decorated with mosaic tiles of blue and yellow, the same as those found across the border. The one divergent note from the typically Islamic mosaic is the use of space between the cedars lined against the white backing.

This is an eighteenth-century tomb, the grave of a woman. A rippling row of cedars interspersed with flowers in bloom—here is the purest reverie of an Islamic garden. Here the soul of the departed is kept in fond memory, gently laid to rest in a carefully kept garden grave.

The mosque of Herat, the great city of western Afghanistan, is replete with blue and purple coloring, as if it were dyed (Fig. 17). The quality of the blue, its utter beauty, is not second to that of the famed royal mosque at Isfahan in Iran. The two times I visited Herat I saw it shining brightly against the autumn sky. While mosques of Iran degenerate into tourist spots, here the fires of faith still burn brightly. I shall never forget the lector's sonorous intoning within the mosque at dawn.

Mosaic tile techniques are not simply a page out of the past. A

mosque lives on; worn or defective tiles have to be replaced, and at times a wall must be entirely renovated. For this work there are the tile craftsmen; and each mosque has a room where they work out new designs or perform repairs. The one I visited was at Herat.

Mosaic tiles are not the kind of small squares we have in my native Japan or those common elsewhere. Here in Afghanistan the pictures of flowers and leaves are composed of small tiles, which themselves have been cut out in the shape of flower patterns and leaves. The tools employed are a kind of hammer with a claw on its side, a file, and a simple hole-borer. With the hammer the craftsman knocks the rough shape out of a piece of blue, brown, or white tile. After this the tile is merely filed smooth. All the work is done by hand. The craftsmanship is a matter of sheer skill in cutting out tile shapes. The finished tiles are then stuck onto the brick wall frame with mortar.

The workshop was dimly lit as we sat watching the workers hammer away. I listened to the talk, took notes, and sketched. In a while, tea was served. They had seemed unsociable at first but now they relaxed into conversation. Each earnestly described his end of the work, proudly displaying the delicate tiles that testified to his personal skill. The tile form seen in Figure 96 gives an idea of the intricacy of some of this work. Into this palm-sized form the crafts-man snugly fits even smaller pieces of tile of different colors. The file is the only tool employed. The cumulative effect of such meticulous craftsmanship is the wonderful wall work we have seen.

Tabriz, the great city of northwestern Iran, was once the capital of the Ilkhan empire. There they have a magnificent mosque that is called the Blue Mosque. It dates back roughly to the thirteenth century. The decorative-tile walls were done in this same way by hand. I went there first a good many years ago. I found it half-destroyed from the Second World War, but the blue, dusty-yellow, and white tiles are still softly molded and beautifully combined. Comparable tile-ornamentation techniques were found in fragments collected

from a wall at Balkh in Afghanistan. Those of Samarkand were identical, which points up the wide distribution of Persian pottery. The techniques were apparently quite advanced at Samarkand and throughout Afghanistan.

Persia, however, has its own way of decorating tiles—the so-called star tile with either four or six points that are joined together to cover a wall. The surface is done with luster or color glazes, and is decorated like any ordinary porcelain. In other words, this is hand artwork with every piece. Use of tiles on walls began in the twelfth century. Luster came first, followed by many color glazes that gave a bright colorful impression. Examples of luster tiles are many. The plate in Figure 5 shows one from thirteenth-century Kashan. These tile designs are raised and completely coated with turquoise glazing, or in the fashion of Sultanabad tiles: in pure blue decorated over with gold colors.

The three tiles shown in these pages (Figs. 13, 77, 78) have a charm all their own. Labeled the "pottery of the enigma," they exemplify the handcraft of Kubachi. There are also, of course, plates, bowls, and so on. Kubachi is a tiny hamlet in the center of where the Caucasus Mountains reach down into Iran from the northeast. The villagers are handy with metal. For centuries, they have made excellent weapons and metal products. No pottery is produced. But about the turn of this century a Russian discovered several hundred pieces of beautifully decorated pottery preserved there. Most of them were spirited away to Russia where they became collector's items.

The feeling and attitude of the figures represented on the tiles illustrate the painting style under the Safavid shahs at the beginning of the sixteenth century. The painting of those times is also in the miniature style. Like *minai* before it, we have here the work of skilled artists; but here the strokes could have been made only by an exceptional hand.

The precise origin of Kubachi pottery is unknown. Why should

it have been made for so short a time in a village of weapon makers? I suppose they may have exchanged weapons for pottery. More likely, the hamlet was a hideout for thieves. It was isolated in the mountains and is especially close to the Caucasus route leading out of Tabriz. Thus the weapons produced here were used on passing caravans and the pottery was among the plunder. Some might argue that the pottery was from Tabriz. After all, Tabriz flourished as the capital during Ilkhan times, and pottery making was at a peak there. However, a ware of so urban an air must be traced further inland to its origins in central Persia. Like the mien of its figured women, the mysterious pottery is still a riddle to be solved.

A mosque decorated with tiles always has its minaret. Sometimes it looks like a chimney of sorts, but even then it is a lovely chimney, inlaid with lovely tile or brick mosaics.

In the heart of the Hindu Kush mountains in central Afghanistan is a minaret (Fig. 18). Here, about the end of the twelfth century, the kingdom of Gorat saw a day of glory. A single minaret remains standing in a deep defile where the center of Gorat was thought to have been. For the most part, the ornamentation is done in arabesque brick mosaics. The section near the top is banded with blue tiles at a height of around eighty meters. It has four tiers, and the twelfth-century inscription of the sultan can be seen in the design.

A French archaeological expedition found the minaret in 1957, after many difficulties. Since that time, an Italian group has been the only one to reach the spot. It is no small feat. When I joined the Kyoto University Archaeological Expedition in 1964 with Kihei Koyama as they set out for the minaret, no Japanese had yet ventured there. We drove for several days deep into the Hindu Kush mountains, urging our jeep on, coming upon hardly any villages along the way. We climbed passes fifteen hundred meters high, continually losing our way and finding it again; up a dry river bed that barely passed for a road, then over a creaky bridge that seemed

ready to collapse. There were steep slopes aplenty, and nights so cold that in the morning the creek was frozen.

Tucked away in this range is the remote village of Jam. There are only fifty dwellings in all with a little creek running with clear, cold water, and beside it the only clearing. The minaret of Jam stood shining in the bright autumn sun. It was something out of a dream. I had seen a picture of it, taken by the French, but I will never forget seeing the real thing soaring before me as we approached the narrow ravine. It was the fourth of October. This is a picture stored within my heart. We reached our objective, and that night we slept well, camping on the village mayor's premises.

The former sweep of the Persian empire, now divided into Iran and Afghanistan, is an extremely arid zone. To live here a man needs water more than anything. Water is the sole indispensable commodity, the mainstay of the oasis. In addition to being arid, the land is as hot as a frying pan.

Even now, unglazed pottery jars are used to hold water here. These are *kuseh,* an ancient word still in use today. Enter any dwelling and you find *kuseh,* large and small, of all shapes and sizes, all filled with water to the brim. Oases always have a huge *kuseh* to refresh the traveler. Since it is of unglazed pottery, it sweats constantly, the droplets evaporating and cooling the water within. In the desert, evaporation is extremely fast and therefore the water chills rapidly. For all the scorching heat and dryness, the water from a *kuseh* is cold and delicious—nectar of the gods. The demand for these vessels is tremendous. Wherever you go, this is the one earthenware item still being made. It is hardly an exaggeration to say that any wisp of smoke over an oasis indicates a *kuseh* kiln. Every town has its pottery stores and bazaars, and the item piled highest is always the *kuseh.*

The use and profusion of *kuseh* cannot at all be considered a symptom of a retarded culture. The *kuseh* is ideal for living in a hot, dry zone. A thermos might be thought a substitute, but a thermos needs

ice; it cannot chill water itself. You would need quantities of ice to make enough cold water. Moreover, a thermos is costly here. The beauty of the *kuseh*, by comparison, is its low price and long life. With the hot, dry climate of Iran, a replacement for this simple jar is yet to be found. Perhaps the relationship between man and pottery was never more profound.

We had a chance to visit a group of *kuseh* potters in Kunduz, a city in northern Afghanistan. There, outside of town, enclosed by long narrow walls, were both living quarters and workshop. Three families were running them as a cooperative pottery. You pass under a dilapidated entry gate; on your right is a long dwelling of sun-dried bricks, a common sight in West Asia; it is the house used by all three families. In the middle is an open area filled with clay materials, some *kuseh*, and earthenware pipes (Fig. 86). Wood was stacked along the walls under a rush-mat awning affair. Beneath it stood the potter's wheels and a place where the clay vessels were given their final shape.

The raw materials are simply lumps of dry clay. A woman beats these continuously, pulverizing the clay with a piece of wood that looks like a boat oar. The powdered clay is then sifted and put into a pit hollowed out of the ground. Water is sprinkled on it, and it is kneaded to a soft consistency. The initial clay preparation is entirely handled by the women. The netting of the sieve is made of leftover strips of thinly cut goatskin, a typically West Asian invention.

The wheel is of the kick type. In West Asia it is usually set into the ground. There are four of these wheels in operation here. The *kuseh* and earthenware pipes are formed on the wheel (Fig. 87). But the larger *kuseh* are slapped into shape, the left hand gripping an eleven-centimeter-long instrument for smoothing the inner surface, while the right spanks the outside surface with a big, paddle-shaped piece of wood (Fig. 88). The paddle surface imparts the pattern. It has curved and horizontal lines that shape and design at the same

time. The beating and the attaching of handles are also the work of women. The whole family works away with hardly a respite.

In one corner of the open area is the kiln (Fig. 91). It is cylindrical and stoked from the bottom, with a fire grate and a compartment for firing. The latter is 1.6 meters across and 1.9 meters deep. The top is left uncovered. The kiln can hold about three hundred *kuseh*, earthenware pipes, and bowls. The fuel is long, dried reeds, something like the sedge that grows in the desert (Fig. 89). This is fed into the furnace for about three hours until the temperature reaches 780°C. or so. Approximately ten hours later, the kiln is emptied. We saw a kiln similar to this earlier at Tepe Siyalk. Ancient kiln types of three thousand years ago live on today, supplying the ever important *kuseh*. Such kilns are, despite their age, surprisingly productive. The day we took kiln temperatures and recorded operations, one kiln turned out 347 pieces in a single firing, and only ten were damaged.

These people seem to work with a vengeance. Things were already under way at sunrise. A man at each wheel, another for the shaping and slapping work, four women for clay preparations and attaching handles—this was the crew. The kiln is called into action every other day, meaning that the inside always stays hot. Once, on a day of firing, together with Kihei Koyama I placed a thermometer inside and made notes. Despite their busy pace, the workmen kept offering us watermelon and tea. They made a point of calling us over whenever they began a new phase of the work, making sure we always got just the right camera shot. Moslem women as a rule will not show their face to a native, much less to a foreigner. But by the second day they seemed completely accustomed to our running around the place. We tried not to make much fuss over them either.

The kiln products were removed at daybreak. Most of the town was still slumbering when we hurried over to the pottery in our jeep. Things had already begun by the time we arrived. The sun was not

yet up. The work went on quietly in the gray light of dawn. Everything was over by 7 A.M. The men once more returned to their wheels and the women got busy at clay preparation. We sat down near the pottery wheels, sipping tea, accepting the meager fare of bread they offered us. The bread these people eat every day is tough, full of wheat hulls, and their teacups are dirty and cracked. The little sugar on hand was given us in a gracious gesture of hospitality. Nothing much in the way of nourishment, but even now I get nostalgic over that plain breakfast amid the good, pungent smell of clay.

NORTH OF KABUL there is a mountain village called Istalif, population: 300. There are twenty-five kilns busily sending up smoke every day. The pottery produced has free, extravagant designs incised under blue and green, low-fired glazes. It is extremely popular in Afghanistan, although delicately made. It is fragile because it is fired at between 800 and 850°C.

Pottery-making in the villages starts up in early April. The people wait till the winter rains and snows stop, then proceed to the mountains to gather clay. Donkeys haul it down to the hamlets. This operation goes on for a month. In this way, a year's supply is laid away.

Istalif in May is a gorgeous green. The poplar, walnut, and apricot trees are leafing out; the snows on the slopes of the Hindu Kush have subsided. With all ingredients on hand, the people, back from the mountains, now go to work in the potteries.

A pottery here is a house constructed of the customary sun-dried bricks. In a corner of the pottery you usually find two kick-type potter's wheels made from poplar or walnut. The village has a carpenter for making the wheels, though it is said that no man uses two in a lifetime. That would require a lot of use. But of course repairs are needed now and then, and the spare wheel is then used.

The shape of the vessels is endowed mainly by the wheel. The dried raw materials are hard, as those at Kunduz. They are powdered,

sprinkled with water, then kneaded for practical use. The vessel that comes off the wheel is then dried, and halfway through the process an iron spatula-type scraper is employed for the final shaping. The scraper is identical to those used in Japan.

When the shape is finished, the slip is applied. The black texture of the body is covered with a layer of white clay. In Persian pottery this "makeup," or slip application, a technique of ancient origin, is still performed today.

The slip is an equal mixture of kaolin and feldspar, diluted in water. For the feldspar, the raw rock is broken into coarse pieces and mashed with a stone mill. This is why you always find a large stone mill off in the corner of a pottery. It is like the stone hand mill we have in Japan, and is sixty-five centimeters in diameter. The stone is turned by hand.

Next comes the glaze. The glazes here are something like Egyptian faience. There are two colors, blue and deep green. A description of the ingredients was relayed to us by the guide who took us out to the spot. He had once studied ceramic techniques in Japan and encouraged the people to give us a rundown. First, the blue glaze: it seems it is one part natural soda, seven parts a combination of feldspar and quartz, two parts kaolin, and one part sheet-copper scrap. The glaze, heavy on silicate, looks like faience. The soda is said to come from northern Afghanistan. I have a certain recollection of seeing many white alkali deposits in the dried-up salt beds and desert surfaces in the arid zones. Those were of the same variety. Two kinds of kaolin are used.

The green glaze is not a far cry from so-called Han-dynasty green. You have one part soda, seven parts a combination of feldspar and quartz, and one part lead acetate. The soda appears to contain boron. The composition again is akin to faience. It is a low-temperature glaze, but not a lead glaze. Bowls and shapes glazed with greens and blues decorate beautifully. The design work is first incised. The

women and children do this job. The patterns are flowers or geo-
metrical designs. Each is done freehand, and no one is the same.

Now for the firing. The kiln of Figure 92 is an earthen, cubic form
built of brick; it is less than two meters high and about two and one-
half to three meters along the sides. The inside is silo shaped. It works
on the Kunduz-kiln principle. The fire stoking room is below, above
it is a firing compartment 1.8 meters across and 1.6 meters deep,
almost the same as at Kunduz. The fire grate has a fifty-centimeter
hole in the center, and many smaller openings all around.

To load the kiln, one person crawls inside through the stoke hole;
another hands down the wares from the top. Small sticks, much like
the kind used in Japan, are used for supports. The dishes and bowls
are turned over on one another for firing. Thin triangular sheets are
fitted in between. No sagger is employed. Stacked full, it will hold
anywhere from five hundred to one thousand pieces.

The fuel is wood scrap of poplar and something that looks like
pine. It is fed in from about 8 A.M. The blaze is gradually built up
over about five hours with twigs of pine. We are now at what we
in Japan call the *aburi,* or grilling stage. Thick smoke pours out of
the kiln, gradually thinning into white wisps. The moisture has left
and now the oxidizing, calcination phase begins. Then thick wood
is fed in and the firing continued another four hours. The kiln yield
is about eighty percent. In other words, twenty percent is calculated
loss. The people of Istalif keep up this pottery-making from May
to October.

A skilled craftman can supposedly turn out eighty bowls, twenty-
five centimeters in diameter, every day. All things considered, he
makes one thousand of them a month. These are sold to the bazaar
merchants for between three and four afghani. The merchant marks
it up another ten afghani for sale. One afghani is equal to two U.S.
cents. This means that two wheels turning full time net about one
hundred and fifty-five dollars in house income per month. But the

number of workers, the family included, runs anywhere from twelve to twenty people. This is truly a poor village.

MORE THAN THESE ancient potteries is responsible for present pottery production in Afghanistan, however. The country has two modern china factories that use Japanese techniques. One is in Kunduz. It makes Spinzar china. Spinzar Ceramics Factory is the name of a great business combine in Afghanistan. Spinzar also runs a large cotton plant in Kunduz, and has a hotel, school, and library. The man who designed and engineered its china factory was Japanese, so it is all Japanese in conception.

All the clays used are of Afghanistan origin and are brought together here. Koyama says they are of excellent quality. The Japanese plan has been carried through faithfully. And the Afghans, too, deserve their share of praise. The factory is in good order, humming with activity, with no Japanese around. The work goes on as always. New designs are constantly coming out and the huge oil-fed kilns are kept going. The shapes we saw were all molded, the items mostly small teapots produced at a rate of about eight hundred per day.

These teapots are made for West Asia. I mentioned earlier that the people here like either black or green tea. It is said that each Afghan has his or her own teapot and teacup. Figure on as many teapots as you have teacups. At this time most of them are still made in Japan. But Spinzar is starting to change all that. In this rapidly modernizing land, china is an important industry. You see women on the job also. In fact it is turning into a women's factory, a near fantasy when you conjure up the Islam of old. No one wears a veil. There is a simple kerchief over the hair, nothing more. Women are also seen more and more in the banks and public offices of Kabul.

Put up against Spinzar, the factory of the Shaker Ceramic Co., Ltd., in Kabul is considerably quieter. The plant site is larger than

Spinzar's, and the layout and equipment are also Japanese. One sees fewer employees; things look a little run-down. Here raw materials are closer by, especially quartz, which can be found in great quantities in the hills behind the factory. Unusually fine conditions—but the spirit is missing. We saw three women making insulators, using molds. The rest of the work was all for tile-making. At Spinzar there are fifty-three men, seventeen women, and six kilns in action. Maybe this place is short of capital. In any case, the fact that these plants exist here says something about the shape of the future in Afghanistan.

THE READER MIGHT wonder what has become of the former pottery centers of Persia: Ray, Kashan, and Saveh. Ancient Ray is no more than barren desert. But in the new city one sees towering chimneys that even give it the appearance of a factory zone. Yet close examination reveals that beneath the tall chimneys are only brick kilns. Teheran has burgeoned into a sprawl of big new buildings and apartments over the last few years. The building materials are no longer sun-dried bricks. Now bricks fired at high temperatures are in demand, and the brick factories are hustling to keep up.

We have said something of Saveh already. In Kashan are the beautiful, tile-decorated ancient bazaars. But the well-made wares of Kashan are absent. All is unglazed *kuseh.* Look for glazed wares at Kerman, Yazd, and other places west of Rareijin.

Production of *qanat,* earthenware frames, rivals that of *kuseh* in Iran. The *qanat* is a tunnel used for conveying water underground. Despite the arid nature of the locale, there are always mountains nearby, their melting snows seeping into the earth to become ground water. If one tries to channel it above ground much will be drawn up into the dry air or back down into the parched earth—a sheer disaster with precious water. The solution has been the *qanat.*

The people first search out a spot where considerable ground water has accumulated. Then a number of pits are dug between it and the

desired irrigation site. The floors of these pits are joined together with *qanat* to form a canal leading all the way to the irrigation fields. Some such canals are said to be thirty kilometers in length. The pits may be seventy, even a hundred meters deep. I am told there are about twenty to thirty thousand kilometers of *qanat* network across Iran.

In case the earth foundation is weak, the pits and the underlinking channel have to be reinforced. For this the *nar,* a mold made from unglazed pottery, is fit into the passage. Because it breaks easily, this form is not made at the kilns, but on the spot.

Should suitable clays appear in the process of digging a channel or a pit, a makeshift kiln arrangement is set up. Sometimes it is just a large hole; sometimes it is sturdily put together with sun-dried bricks. The *nar* is kneaded from clay and shaped. It is ellipsoidal with a major axis of one meter and a minor axis of one-half meter, and is approximately thirty centimeters high. The fuel is whatever can be scrounged from nearby fields—grass, shrubs, and the like. Following firing, these *nar* are fitted snugly together and the joints sealed with clay. That is all there is to it.

On a trip there in 1959, I inspected the kilns of Rareijin in southeast Iran. These were cylindrical in shape. The interesting feature was that, in the center, jutting out from the inside walls, were many poles made of pottery positioned so as to form a shelf on which the wares could be placed in the firing compartment. The glazes used were either a monochrome of turquoise or polychrome. The shapes and colors were marvelously Persian; proof may be found in the bowls and pitcher of Figures 80, 81, and 84. The roads of Rareijin were a shining path of blue fragments sparkling in the sun, really something you might expect of a pottery town. The town's smoldering white kilns come to mind even now.

The water pitcher of Figure 79 is from Yazd. It is completely glazed in brown gone black. The shape is Sassanian, definitely rem-

iniscent of the cock's-head pitcher of Persia. Tradition still runs deep. The three-colored design in Figure 81 might be termed the old Persian bird theme revisited. Again in Figure 83 you have the Chinese effect, a plate with a floral pattern, but obviously invoking the Persian design tradition. The whole is in turquoise, the flowers delineated with black, and a stylized script in the center—another pure throwback from Persian history. At Kerman, a rather poor, Chinese-type ceramic with deep cobalt on white was fired. Thick and somewhat ponderous, it stood tall, as if to tell of times long past.

The toy cavalrymen in Figure 82 are from Istalif. These figurines, the specialty here, are curios, and look like a potter's plaything. They are quite fragile and easily broken. The people think of them simply as toys, yet they evoke far more than the feeling of toys.

There is a district called Nuristan in southwest Afghanistan, set deep among the mountains amid heavy vegetation and forests. You find there strange figurines from an old wood-carving tradition. The execution is rather rough; and they are mostly of horse and rider. "Ancestral gods," they told me. But doesn't this recall our horse-and-rider "toys"? And what about the king-and-horse or soldier-and-horse motif in Sassanian silverware as well as in Persian pottery design? One notices here that the handling of the neck, eyes, and mane are like that of prehistoric bronzeware. A world so caught up in Islam still shows, here and there, signs of pre-Islamic culture cropping up.

I think of the beauty of the prehistoric and the early Islamic arts in terms of calligraphy. In the Persian prehistoric and Sassanian times, it is the beauty of the straight line; with Islam it is the beauty of the supple and cursive line. In the course of Persian art there is the hard, strong beauty of prehistoric earthenware form: Sassanian silver craft has a discipline, a severity of expression. By comparison I think you would have to say the Islamic wares, while being a blaze of color, and undeniably very interesting, are a deterioration, a softening per-

haps, a steady decline since the dawn of its history. No longer a formal beauty, Islamic art is based on the lovely play of color and line. Pottery has entered the practical domain of daily use. In the public, that is religious, sphere, metal wares predominate, and this is surely a factor in the decline.

All this is another way of saying that the real beauty of Islam is in buildings—architecture. It is epitomized in the mosques wherein the one and only Allah is praised. In the decorated pottery of modern tiling (Fig. 85) one finds a measured beauty in simple space that even in today's metropolis is an insistent reminder of Allah's presence.

CHAPTER THREE
JOURNEY
TO HORMUZ

THE PERSIAN GULF ALWAYS churns up in the afternoon. On two occasions in 1959 the waters thwarted my crossing to the island of Hormuz. Hormuz is a tiny isle just offshore from the port of Bandar Abbas, looking out on the Persian Gulf. It has about twenty kilometers of coastline. Nearly all of the isle is bleached rock salt and iron oxide, worn from the unkind sun and salt breezes of the Gulf. It has no springs; the islanders have to catch rainwater for use.

Hormuz is a poor, lonely place now, but it was once a harbor known round the world, a place where trade brought East and West together. The poet Milton alluded to it in *Paradise Lost,* saying that were the world a ring, this would be its diamond—that was Hormuz once upon a time.

About fifty years ago the intrepid Englishman Aurel Stein took a huge caravan into Iran by way of Baluchistan in western Pakistan. He covered the whole of southern Iran in his explorations, finally reaching the shores of Hormuz to look for the ruins of the former harbor city. Stein wrote of countless shards of Chinese porcelain scattered about there. He then moved along the southern shore of the Persian Gulf, arriving at Tahili. The old name for Tahili is Shiraf; it was also a key port for East-West trade. Until now no one had traced Stein's footsteps to Hormuz.

In the fall of 1964, I went with Kihei Koyama and Shosin Kuwa-yama down the west bank of the Indus to enter Baluchistan. Re-investigating the prehistoric remains uncovered by Stein, we pro-ceeded westward. Baluchistan was already bitter cold. We fought winds of –10°C each day in our little jeep. It was an unrelenting roll of hard hills and barren land with only an occasional village now and then inhabited by the Baluchi tribe. All along the way we stopped to gather shards of color-decorated pottery as we moved on toward the Iran-Pakistani border. We came into the vast wilder-ness of the Margo Desert. Here Kuwayama turned back and headed eastward.

The mountains of Iran were white with snow. From time to time blizzards blocked our way. The raw wind clawed at the seemingly endless stretch as we tried to push on in our jeep. We hardly saw a truck. We passed Kerman, moving south to Bandar Abbas, then reached the Gulf at last on the nineteenth of December. I had been in Bandar Abbas in the summer of 1959, and had been twice defeated in attempts to cross to Hormuz. Bandar Abbas was a sad, lonely town to me then, for I had come to pick up where Stein left off in the ruins and had to give up.

The history of Hormuz began in the tenth century. The city of that time was not located on the present island but was closer to Minab, a town southeast of Bandar Abbas. The products of southern Iran were sent to India. Horse-trading flourished. Marco Polo, the great traveler, came through here twice, in 1272 and 1293, making mention of the horse trade en route. From India came gold, spices, precious stones, and ivory; from China, silks and porcelain. Like the Silk Road that links the deserts, the Silk Road skirting the sea made Hormuz a key trading port.

Looking for the first Hormuz ruins, we turned our jeep south toward Minab. Marshland stretched out on either side of the road; sometimes we saw patches of salty white here and there. We had

driven along in snowstorms in and around Kerman; now here we were mopping our brows along the Gulf in December. Finally, a large palm grove came into view. "Around Hormuz, there are big date plantations," so runs the old record, and these were probably them; but only two or three palm-thatched huts were left.

Once out of the grove, there was a large river. This too is called Minab. The city came into sight now, and on one edge you could see a hill with an old castle. The river in front of us had no bridge, so the jeep sliced into the water, sending up a spray on either side. Up the other bank we went and were soon at the city gate. Bazaars were scarce; the town was badly run-down.

We headed on toward the castle. A boy ran out, offering to show us the way. Freed of the narrow little road jammed with houses, we reached the rampart. The castle was completely in decay. The earth crumbled to gravel under our feet so that we had to crawl our way up on all fours. Still, it was not that far to climb.

Except for one round lookout tower, the remainder of the fortress had gone utterly to pieces. Among shards of Islamic pottery scattered about, my eye was caught immediately by those of white porcelain. The surface of these was bright royal blue, unmistakably Chinese in origin. We inched along inside the castle, watching our step as we went, picking up exquisite fragments one after another. One was of celadon porcelain. All were blue and white of Ming descent. The vessels these came from were once carried from some far port in the Orient. I had come looking for—and had found my little voyager from the East.

"*Top! Top!*" the boy kept shouting. *Top* means "cannon" in Persian. We made our way around the crumbling edifice to find, half-buried in a large crevice, a fallen cannon. It had about an eight-centimeter bore. The rifling was still intact. It must have been a remnant of sixteenth-century Portuguese rule. I looked out to gaze at the lazy Minab winding gently below me and saw that the two

sides of the castle formed sheer cliffs overlooking it. This had surely been a bastion once.

The sun set with the palm trees silhouetted sharply against the crimson sky. The latter glowed deep, now deeper scarlet. I had seen a sky like that once on the Indian Ocean, a blood-red sunset against a ruby sky. The sun setting on the Persian Gulf was the same—a gash of ghostly crimson.

WE WENT OUT of Minab into white, parched wastelands. Scorched by the sun and exposed to gusts from the Gulf, the feeble vegetation clings to the earth for dear life. Before us lay the bare trace of a ragged road. We pushed our jeep onward in search of Kare-Sarawan and Kare-Qunbil, the names Stein used in his record for the ancient ruins of the first city of Hormuz. We met a swirling dust storm, stopped to ask people the way, and finally emerged from the wastes into a vast marshland. At the far end you could make out the dim outline of an oasis overgrown with trees. That would have to be Kare-Sarawan.

Our jeep started slipping the minute it hit the marshy ground. The wheels spun helplessly in the oozy earth. I got out and walked. With less weight aboard, the wheels grabbed and the jeep inched ahead. My shoes were a mass of clinging mud. I made very sure of where I stepped since there were quicksand pits. My eyes were riveted to the ground.

We made it to Kare-Sarawan, which was no more than a meager stand of palms with a few huts underneath. Two men gave us blank stares. A couple of chickens pecked about and the slender palms seemed to teeter overhead. But there was a scattering of shards on the ground: we were surely on the trail of the ruins.

A man said that the site was beyond the village. Our jeep covered a stretch of grassland about one kilometer wide before reaching a series of low hillocks sprinkled with pottery fragments. This was it—

the ground was a sea of shards. For two kilometers north and south and one and one-half kilometers east and west there were about twenty low-lying mounds. This had been the heart of Hormuz, the ancient city Marco Polo had visited (Fig. 108).

The earthenware fragments were interspersed with bright-colored bits of Islamic pottery. There were pieces with luster glazes, and pieces that looked like they might be either Yuan or Ming were mixed in with the Islamic shards. There were also wonderful remains of celadon and white porcelain. Moreover, much colored glass was on hand, especially pieces from bracelets with gold or crimson glaze-work fired on. Bits of bronzeware and large iron arrowheads were there also.

All this fits in with Stein's account. However he called this place Kare-Qunbil. Strange. We finished our fragment-collecting and returned to the village to check on the name. The people called it Kare-Sarawan. So on to Kare-Qunbil. The villagers pointed the way and we set out, covering some four kilometers in the general direction. Then we came upon dunes rolling down to the sea, strewn with shards of earthenware and broken brick. This was what Stein had been calling Kare-Sarawan, but was most certainly Kare-Qunbil. He probably mistook the name the people gave him. Aside from the appellation, his description matches the spot perfectly. Perhaps the poor man was as exhausted as we were about this time.

THE SUN BEGAN its descent. Hormuz, the first city and port where East and West had once met, was now a bygone, buried world, a grave blown by breezes from the Gulf. It is vast and uninhabited; only Time seems endlessly to move across its remains. City of no visitors since Stein, it held us, and released us but reluctantly as the sun sank scarlet once more.

In 1301, because of the Mongol threat, the first Hormuz was abandoned. The new city was built on the tiny island of Hormuz.

This was the isle of my dreams, as I admitted once before. The new Hormuz, as a port, enjoyed even more prosperity than before. A legion of visitors came to call and record the gaiety and grandeur of the town. Homes of the aristocracy displayed vases of cloisonné, furniture inlaid in Indian style, and Chinese jars of floral decoration.

Hormuz flourished for some two hundred years. But the grasping European powers could no longer bypass the famed port. In the early sixteenth century the Portuguese reached its shores and promptly placed it under control. They built a strong fort there and soon began reaping immense profits from the East-West trade.

About a century after, the Iranian Safavids linked up with England to drive the Portuguese out. Hormuz, along with Bandar Abbas just across on the mainland, soon regained its trading position. But history was moving quickly now. There was the advent of steam, and a switch in world shipping lanes. The opening of the Suez Canal all but finished the relevance of the Persian Gulf in international shipping. Hormuz began to fade. Forty thousand in population at one time, by the mid-nineteenth century the once glamorous city, from all accounts, dwindled to but four hundred persons.

At its apogee, Hormuz was of course no stranger to China. The Chinese called it Hu-ro-su-mo, the four characters quite close in sound both to the Persian and English names. Chinese ships came to call, especially during the Yung-lo era of the Ming dynasty. The seventh voyage of the renowned admiral Cheng-ho, also of the Ming dynasty, has been carefully recorded.

It is quite understandable then that, as with the first Hormuz, there would be Chinese porcelain fragments here. We managed to charter a fishing boat and make the two-hour crossing, setting foot on the island at last. The Portuguese citadel still stands, but its insides are crumbling. The iron oxide on the island gives the fortress a burnt, red hue, adding to the ancient appearance (Fig. 107).

The arrangement of the fort is straight out of medieval Europe.

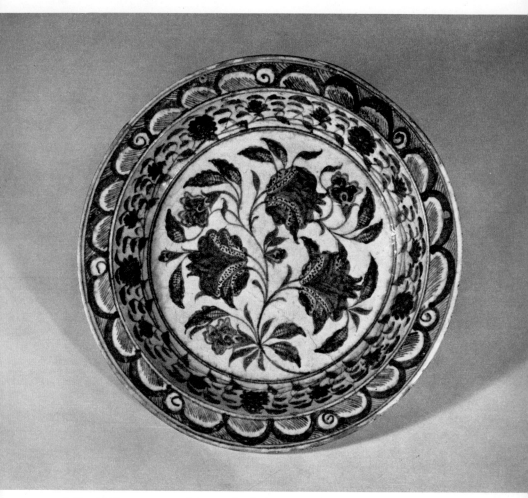

97. Dish with blue pomegranate design on white background. Isfahan. Seventeenth century. Height, 6.2 cm.; diameter, 35.5 cm.

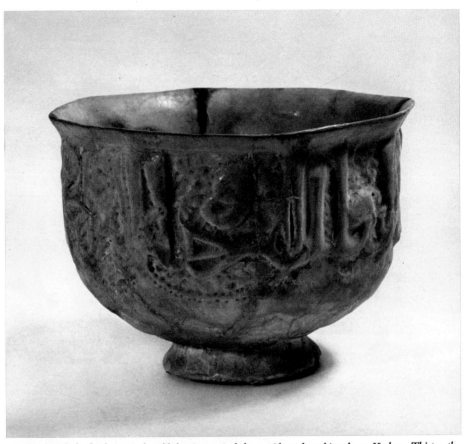

98. Bowl with firefly design and molded script around the outside under white glaze. Kashan. Thirteenth century. Height, 11.2 cm.; diameter, 15.6 cm.

99 (opposite page, top). Bowl with transparent blue-and-white glaze and incised cloud design. Kashan. ▷
Twelfth century. Height, 7.1 cm.; diameter, 16 cm.

100 (opposite page, bottom). Bowl with white glaze and blue lines. Ray. Thirteenth century. Height, ▷
6.2 cm.; diameter, 15.2 cm.

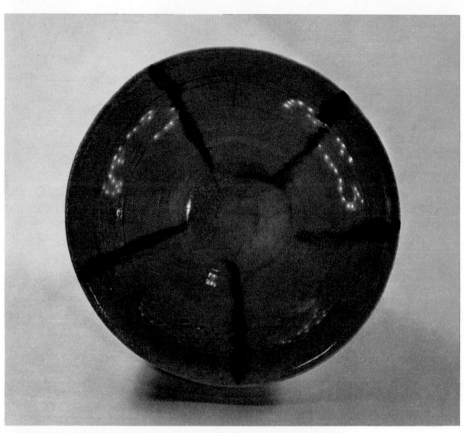

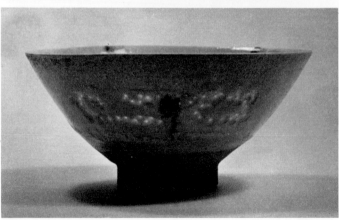

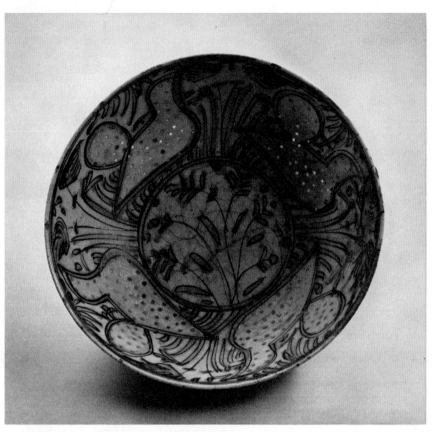

102. *Multicolored bowl with firefly decoration and flower-and-bird designs. Kerman. Seventeenth century. Height, 8.9 cm.; diameter, 22.7 cm. Tenri Museum, Tenri, Nara Prefecture.*

◁ 101 *(opposite page). Two views of firefly-design bowl with white glaze and blue lines. Kashan. Twelfth century. Height, 7.3 cm.; diameter, 15.5 cm.*

103. Chinese shards collected at the castle in Minab.

104. Chinese shards collected at Kare-Sarawan.

105. Chinese shards collected at Hormuz.

106. Chinese shards collected at Hormuz.

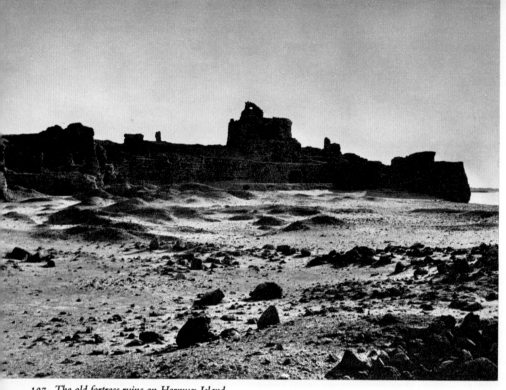

107. The old fortress ruins on Hormuz Island.

108. At Kare-Sarawan: the hillocks in the distance indicate the site of the ancient city of Hormuz.

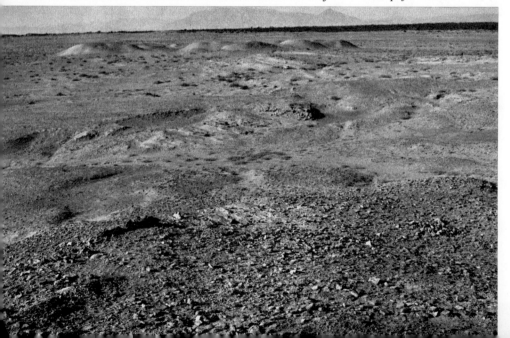

The area around the inner court is lined with living quarters built of stone. The materials employed include coral, which lends a distinctly South Seas touch. In the center of the open area is a deep-sunk, stone water reservoir. Rainwater was obviously the elixir of life on this springless island.

The further into the fortress, the more deterioration there is. Cannon after cannon rusts away in the salt air, buried in the ground, or left to corrode on the ramparts. The cast marks and inscriptions are completely illegible. I came across a huge cannonball shell. The pervasive smell of the sea was everywhere. Even the stones that shored up the sides of the citadel are thickly encrusted with salt.

The fortress contained much in the way of Chinese porcelain fragments. As history has it, these are relatively new; almost all from Ming, from the Chia-ching era (1522–66), and there were some with a transparent glaze painted over designs. There was hardly any celadon; most was porcelain with designs under a sheer glaze. A portion of the shards I gathered are seen in Figures 103–106. The popularity and ubiquity of Chinese blue-and-white, carried all the way to Iran by boat, is obvious even from these.

Blue-and-white china was transported by land or sea via the Silk Road. The gorgeous blue lavished on the pure white of porcelain was a combination loved equally in Europe and Islamic countries. In the Topkapi Sarai Museum in Istanbul there is a large collection of Yuan and Ming blue-and-white porcelains. The latter are also famous at the Ardebil mosque in northwest Iran near Tabriz. There are 618 pieces, plus 80 of white porcelain, 58 celadon, 16 yellow, 23 polychrome, 7 deep blue, and 3 dark brown, totaling 805 pieces in all. Pope lists 320 in the category of dishes. You find more in the Archaeological Museum in Teheran. Yuan and Ming wares are grouped together there: color glazes over white porcelain, celadon and white china, and red ornamented types. There are also elegant items in the Palace of the Forty Columns of the national museum of

Isfahan. Don't forget the fine celadon and red decorated wares of
Chinese style at Tabriz University, or at the museum of Meshed in
the east. Among this Chinese-style work one notices a deliberate at-
tempt to reach the Islamic market by using Arabic script decoration.
Obviously these were export items. Over and above all these, I
gathered numerous Chinese porcelain fragments at various remains
in Iran and Afghanistan. I was utterly taken by surprise by a bazaar
building I happened upon in Tashkurgan in northern Afghanistan.
The ceiling of the main dome was completely covered with Chinese
cups and bowls. There were some of Ch'ing decoration. All the cups
and dishes stuck on the ceiling were intact, leaving me with an odd
feeling. I saw this kind of decoration once in Thailand at the famous
temple of Wat Arun. The colossal pagoda and buildings, even the
statues, were all decorated with porcelain shards. Stop to contem-
plate how many fragments it would take for the feat. Then suppose,
as is evident from closer scrutiny, that whole pieces were broken on
purpose just for effect. Many of these were reputedly Ch'ing.

The way Chinese porcelain won over the West, especially by color
designs under transparent glazes, was bound to affect Persian pottery.
Shah Abbas, the most important ruler of the Safavid dynasty, came
to power in 1587. A diligent ruler, he was aware of the European
affection for Chinese porcelain and he decided he would produce the
same kind for export, hoping to profit by it. He brought in a group
of Chinese potters and their families to provide the technical guidance
necessary. In this way was born a Persian pottery made completely
in the typically Chinese fashion: designs under transparent glaze. But
the step to porcelain was still beyond the Persians.

Shah Abbas's business appears to have fared well. Accounts from
the Dutch East India Company of Batavia (present Djakarta) men-
tion the Persian pottery of the times. In the forefront was the wonder-
ful work of Kerman. It was said to differ but slightly from the Chi-
nese, according to another record. This Persian "Chinese" ware

reached Europe via the Batavia route. In 1665, 4,646 pieces were shipped, and in 1668, another 2,268. In 1681, Kerman dishes sent to Batavia numbered 4,556 in all. It is said that this ware was brought as far as Nagasaki in 1669 but was denied entry to Japan.

The Chinese-style porcelains which the Dutch East India traders handled were made in China and Japan. What Persia produced came along more or less for the ride: it was not porcelain and it gave off a poor ring. The Persian kilns were small compared with those in China and Japan. Pricewise, Persian pottery simply could not compete, so its exports began to dwindle. The stream of outgoing items lasted about twenty-five years, with exports averaging about fifteen hundred pieces per year. Interestingly, red-oxide pigment made its way to Japan via the Batavian route. You can still find this color in Chinese-styled wares in the antique stores of Iran. The background is a cream color of cloudy white consistency. There are the typical Chinese landscapes, floral designs, and multitiered buildings done in rich cobalt. A closer glance reveals they just might be taken for the genuine Chinese product, the detail is so fine. An example can be seen in the dish in Figure 97, where you note a large pomegranate design in the center—really Ming revisited. At the same time, the pomegranate design is a child of Western influence.

But it was not all Chinese-style wares. When three-color techniques were used in China, much celadon and white porcelain came to the West. Porcelains from Yueh kilns were preferred. Porcelain was the special invention of China: the West tried hard to imitate it but failed. Highly vitrified, durable, and beautiful, it was something unheard of in pottery elsewhere. The outflow began with the Sung dynasty (960–1279) and continued afterwards. Celadon, white porcelain, and blue-and-white ware were all exported in vast amounts. The greatest producers were the Lung-ch'uan kilns of Ching-te-cheng. Beginning with the Yuan dynasty, the blue-and-white also began to be shipped to Iran and on to Europe.

The Chinese porcelain techniques are another problem. A transparent glaze was employed. Before applying the glaze, a design with cobalt or other colors was painted underneath. In other words you have artwork under glaze. This is entirely different from subsequent coloring methods, which first applied the glaze, and added the coloring later, before firing. Which was it—East or West, that first put colors *under* glaze? As far as is presently known, the world's oldest instance of this is a bottle dated with an inscription from the ninety-first year of the Yuan dynasty (1351). It shows extremely developed techniques as well as very precise design work. Strange to say, we have no knowledge of any precursors that would show us more elementary examples.

Assume rather that techniques for artwork under glaze originated somewhere else and you are on the right track. The West had these methods quite early. In the Tutankhamen exhibit that was shown in Japan, I saw a small amulet glazed in turquoise. The glaze was labeled faience. It could have passed for glass, since it contained 80 to 90 percent silicic acid. Those who saw it might recall the line work done in cobalt under the glaze. I think you have here the oldest existing color under glaze. The techniques for its later forms, of around the ninth century, were greatly in vogue in West Asia.

These techniques gradually found their way to China, where the Chinese had already perfected both porcelain and transparent glazes. I think we have to conclude that they had now come across something new to add to their bag of tricks. The recent excavations of ancient kilns in China have made us rewrite the history of porcelain. The kilns of Ch'ang-sha (an ancient river port of the T'ang dynasty) that are supposed to have fired porcelain with underglaze decoration are sure to draw attention. They produced ceramic pillows with floral designs of hazy dark brown and green under the transparent glaze and pitchers with a palm-tree-like pattern in greenish brown under blue celadon. We are left with the feeling that both

these artifacts were attempts at painting under glaze. These attempts continued into the Yuan dynasty.

The vase with cobalt-color under-glaze decoration and a dated inscription, and pieces whose patterns are made by painting with cobalt pigments, most likely came after long and strenuous efforts in search of glaze-over-painting techniques. And when Mongol rule ended in Persia, what was called Islamic blue, a superb cobalt, came in from the East; the contrast of the simple colors, blue on white, gave birth to the porcelain we know so well.

This process applies to more than this one technique. The Yuan and Ming designs of this type are more Persian than Chinese as far as tradition goes. The method of exact geometrical plotting of space, filling in each with patterns, is the opposite of the feeling for white background and space which one finds in celadon and white porcelain up to this point. Dividing an area into large medallions and painting in these Chinese-style grapes, pomegranates, watermelons, and palms—this is clearly evidence of Islamic influence. Are not the inscriptions, "long life" or "ten thousand years" none other than the sacred Arabic verses of Islam revived in another form?

In China the techniques for painting over glaze, using the "hard colors" of Ming and the "soft colors" of Ch'ing, developed by leaps and bounds. The principle was to paint patterns over glaze on porcelain, then refire the piece. Multicolored painting followed by firing is, needless to say, the same method used with Islamic *minai* pottery. But here we note that the entire surface of the vessel is covered: surely the influence of Islam upon Chinese techniques. The vessels sprinkled with the golden hue known as "gold brocade" are identical to those of Lajvardina. Precisely because of these similarities, the popular design-under-glaze of Ming and the colored wares of Ch'ing were warmly welcomed in the West.

The influence of Islamic pottery was not limited to China alone. Until the fifteenth century the Mediterranean coast was completely

under Moslem control. With Spanish Cordoba as its center, a great Islamic culture came to flower, and the techniques of Islamic pottery spread to the West. Majolica, the name for a favorite pottery of Western tastes, is a remnant in name of Islamic pottery. In the age of Chinese, Persian, Mediterranean, and Islamic pottery, East and West took on the same shining colors, traded tastes for beauty in both color and diverse design.

In the wake of this commixture, albeit a confusion of tastes, a tiny firefly flew into Islamic wares. Small holes were opened in the sides of a piece of pottery and then white glaze was applied over the opening. The thin glaze allowed light to glow through (Fig. 101). Was it the fancy of East or West that delighted in this delicate dance of light? In *The Tale of Genji,* the celebrated eleventh-century Japanese novel, we read of an elegant lover's game in the imperial court: a firefly slipped into the sleeve of a kimono was held up before one's lady fair to illumine her face ever so gently in its pale blue light. Persian courtiers enjoyed something similar. Double palace walls allowed the inner side to be cut out to form a pattern, behind which a row of lighted candles could be placed. The play of light and shadow must have pleased all. And at the Mughal court people enjoyed the evening light that shone through lattices or patterns cut into a piece of hollowed marble. It seems that courtiers of both East and West could be charmed by the little lightning bug.

Figure 98 offers a view of "firefly pottery." The Chinese designs and script on the outside are mold work. The white glaze is extremely thin. And the shape is certainly Chinese in style. From Kashan? Figure 100 shows a kind of delicately crafted bowl with clear lines radiating from the center. It is something quite common. The bowl of Figure 101 is superbly done in Chinese style, a firefly bowl of delicate fashioning with a disciplined profile. The tall footing with all such pieces is hollow inside and left unglazed—in imitation of Chinese techniques. Ancient footing was not hollowed out as a rule.

The bowl of Figure 99, with transparent glaze of blue and white in the Ying-Ch'ing manner (porcelains with pearl-blue glaze) and with an incised cloud design, is so Chinese in appearance that it would be impossible to doubt its origin.

The bowl in Figure 102 is an imitation of the blue-and-white made under the reign of the Safavids. It is an attempt to copy, just as is the large floral-design piece in Figure 97. It has firefly work all over and is firm, highly vitrified, with a flowering plant design in the center and four birds around the inside. The brushwork is accomplished. It is a product of the Shah Abbas period, quite surely from Kerman.

ISLAM IS ONE religion, one world. The world of the one and only Allah from this point of view has a certain homogeneity. But from another, its history, its location, the inclinations of its faithful wherever they are, makes Islam quite heterogeneous. In particular, under the Ilkhans, Persia had direct contact with China through the Mongols whose subject she was. Persia was thus the country closest to the East. The Silk Road, land or sea, fostered cultural exchange in both directions. However, in the long history since Achaemenian times, it was Persia that wielded the traditional scepter over West Asia. Its culture was created and accepted. There was give and take, coming and going. This dialogue formed the one culture that nurtured all that was to bear the name Persian pottery.

The "weathermark"
identifies this book as having been
planned, designed, and produced at
the Tokyo offices of
John Weatherhill, Inc.
7-6-13 Roppongi, Minato-ku, Tokyo 106
Book design, typography, and layout of
photographs by Ronald V. Bell
Color and gravure plates engraved
and printed by Nissha Printing Co., Kyoto
Composition and letterpress printing
by General Printing Co., Yokohama
Binding by Makoto Binderies, Tokyo
Text in 12-point Monotype Bembo
with hand-set Perpetua for display

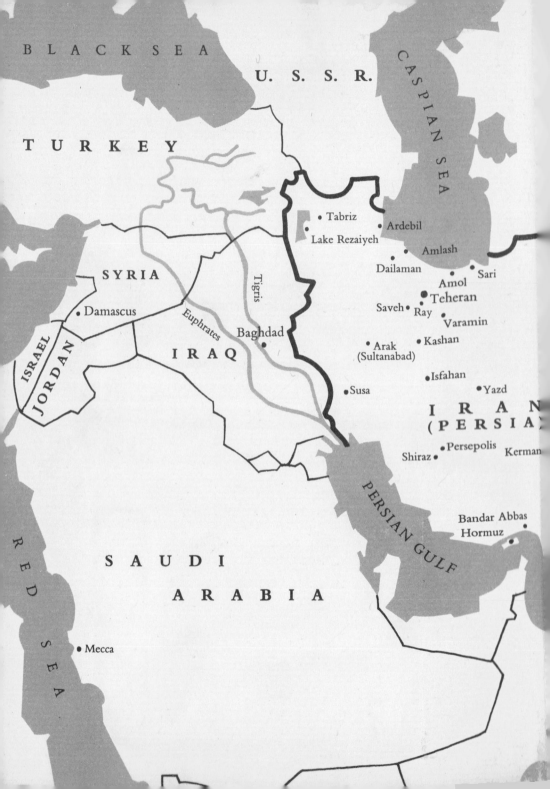